D0890348

POSTCARD HISTORY SERIES

Mount Clemens
Bath City, U.S.A.
IN VINTAGE POSTCARDS

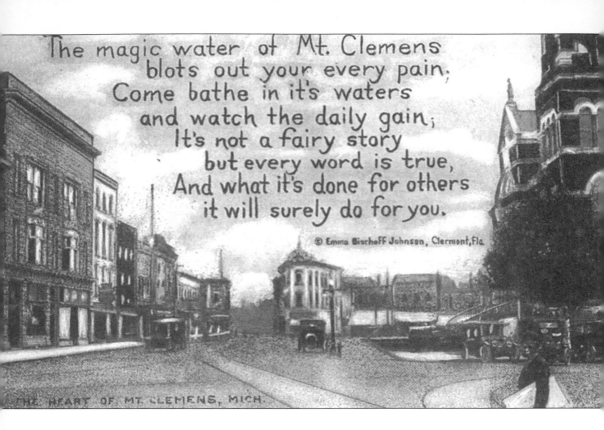

The magic water of Mt. Clemens
blots out your every pain;
Come bathe in it's waters
and watch the daily gain;
It's not a fairy story
but every word is true,
And what it's done for others
it will surely do for you.

© Emma Bischoff Johnson, Clermont, Fla.

THE HEART OF MT. CLEMENS, MICH.

POSTCARD HISTORY SERIES

Mount Clemens
Bath City, U.S.A.
IN VINTAGE POSTCARDS

Marie Ling McDougal

ARCADIA

Copyright © 2000 by Marie Ling McDougal.
ISBN 0-7385-0829-2

Published by Arcadia Publishing,
an imprint of Tempus Publishing, Inc.
3047 N. Lincoln Ave., Suite 410
Chicago, IL 60657

Printed in Great Britain.

Library of Congress Catalog Card Number: 00-107784

For all general information contact Arcadia Publishing at:
Telephone 843-853-2070
Fax 843-853-0044
E-Mail sales@arcadiapublishing.com

For customer service and orders:
Toll-Free 1-888-313-2665

Visit us on the internet at http://www.arcadiapublishing.com

DEDICATION

This book is dedicated to the memory of Norm Lorway, without whose passion for the days of the Bath City, this book would not exist. When Norm first started collecting Mount Clemens postcards and other bath-era memorabilia, he probably didn't know how they would consume his later years. Norm became an advocate for the remnants of the bath house days, a public speaker on local history, and a historical narrator for the Clinton River Cruise ships. He spoke to school children and adults and, in fact, anyone who would listen. When he had met enough people who shared his interest, he founded the Bath City Collectors. He was president of the group of memorabilia collectors until his death. Most importantly, Norm collected, organized, and made sense of hundreds of Bath City postcards, many of which appear in this book.

CONTENTS

ACKNOWLEDGMENTS

I would like to thank the people who provided postcards for this book, especially the family of Norm Lorway. Bath City Collectors members; Deanna Black, Robert F. Rinke, and Pat Kimmel; were invaluable. Bert Lozen, Donna Bolster, Cindy Donahue, Arlene Rood, and Nelly Longstaff shared their collections and recollections. A special thanks goes to Madeline Page and the Crocker House collection for helping me fill the gaps. My sincere gratitude goes to my super photographer, Mike Robinson of Robinson Photography, and Pete Williams of PAW Graphics, my former student who dropped back into my life just when I needed his expertise the most. And then there was Scott Pardon, who stopped by and lent a hand.

AUTHOR'S NOTE

This book is not meant to be a definitive history of the bath era of Mount Clemens. It is merely an effort to recapture the images of a bygone age. I do remember the stench of the later years of the bath era. Who could forget? I don't, however, remember many of the bath houses and hotels pictured in this book. Therefore, I have relied on the writers of the time and local historians who tried to keep the Bath City alive, in print if no place else. I have also relied on the memories of our wonderful seniors. I would like to thank all those who provided information for this book and hope that it is as accurate as history written by those who did not live it is apt to be.

COVER IMAGE: John Henry Schelling was the second chief of police in Mount Clemens. In this 1913 postcard, he appears to be way ahead of his time, keeping an eye on his city from the air. Or is this just a postcard photographic hoax?

INTRODUCTION

In October of 1880, when Mount Clemens' mayor, George Crocker, said, "My friends—all roads lead to the court house," he could not have had a premonition that Mount Clemens would become anything more important than the county seat. Little did he know that before the century was over, all roads—and interurban lines and railroad tracks—would lead to Mount Clemens bath houses and hotels.

According to legend, the city owed its fame and good fortune to a bone-weary old horse. He was, no doubt, a good horse so farmer Bassett put him out to pasture to live the rest of his days in leisure. As the story goes, he apparently liked the lazy days but not the aggravating flies and scorching sun. He found his peace, however, in the shade of an old water tank—a leaky water tank. He also found relief and rejuvenation.

The water tank was a remnant of a futile attempt to extract oil, and then salt, from the depths below the city. Much to his disgust, all Charles Steffens could find was water. Since the water contained three percent salt, the Mount Clemens Salt Company was founded in 1861. Unfortunately, salt was not the only mineral contained in the water. In fact, the water was so impregnated with minerals that the idea of producing commercial quality salt from the water was abandoned.

The tank was left to drip and provide an inviting mud hole in which farmer Bassett's horse loved to wallow. Of course, there is another story that might seem more plausible to skeptics. This tale involves an old sailor with a bad case of eczema. Dorr Kellogg remembered that his skin improved when he sailed the seas and bathed in saltwater, so he decided to give the Mount Clemens mineral water a try. While he had faith in the curative powers, apparently others did not.

In his own words, Kellogg's story goes like this. "I came here in October 1870, and in December of that year I rigged up a couple of bath tubs in the old salt blocks. Some of the men who have in late years been heralded as discoverers of the water warned me it was no good. But I went on and after a lot of cures had been made, they endured, and they embraced. I am going to have my picture taken as the real Columbus."

No matter who gets the credit for the discovery, it was Dr. Henry Taylor who took the initiative of seeing that the first bath house was built. He built it, and they came, from neighboring states and from far-away countries with unfamiliar names. Those with ailments of every kind came looking for the "magic water," for the cure, for relief. Some found that relief and some did not. Whatever the result for the bather, the Bath

Era brought prosperity and fame to the town that would be known around the world as "Bath City, USA."

This book is divided into six chapters. The first chapter, Bath Houses and Related Hotels, features postcards of all but one of the major bath houses which made the city famous. The only reason the Eureka is not pictured here is that no postcard or picture was available in the collections used for this book. Since the bath house and the connected Northwestern Hotel have a fascinating history, they will be the first businesses to be discussed. In the early 1900s when George I. Hutchinson came to Mount Clemens, he just wanted to take a bath. He was not allowed to bathe in the city's curative waters, however, because he was black.

Luckily, Hutchinson was in a position to right this wrong. He bought the hotel and welcomed those of his race to come bathe in his therapeutic waters. For a short period the business was known as the B.T. Washington Hotel, and when Henry Lightbourne took over, he changed the name to the Mount Clemens Hotel and Central Mineral Bath House. A fire in 1929 set Lightbourne back for a few years, but he reopened the hotel in 1935 and ran it until 1963, when it was demolished to make room for highway expansion. The map at the end of this chapter is to help with locations since so many streets have undergone name changes. The maps in this book were created by Norm Lorway.

The second chapter, Bath House Humor, would not have been possible except for the efforts of Harry W. Longstaff. Without Longstaff's postcards there wouldn't be enough humor cards to warrant a separate chapter. Luckily Harry needed a job when he was just out of high school and studying to be an architect. In his free time, he drew cartoons for the *Mount Clemens Monitor*. It was his love of cartooning, no doubt, that led him to publish two sets of postcards depicting the Bath Era in a slightly less than serious tone. They were done primarily in an interesting combination of yellow, orange/red, and black. Although Longstaff's cards are humorous, the text that accompanies them is serious. It strives to give the reader an understanding of the way baths were given and why.

Chapter Three represents the hotel industry but covers only a fraction of the hotels that the city's bathers called home. Despite a search of numerous postcard collections, these were the only images available. Perhaps not all of the 78 hotels in the city used postcards to advertise their business. Perhaps the missing hotel postcards just haven't made their way back to the Mount Clemens collectors who lent their cards for this project.

Chapter Four depicts the Mineral Springs that played a major role in the health spa reputation the city enjoyed. Bathers came to the city, took their baths, and sat comfortably sipping water at several springs set up to promote rest and relaxation. Again, all springs are not represented pictorially. Some of the springs not pictured here are the Ambrosia, Arbor, Imperial, Maple Leaf, Orchard, and the famous Peerless Springs. A map has been provided at the end of the chapter.

All of the activity was not centered in the city proper. Chapter Five covers the postcards available for the hotels in nearby Harrison Township. Since the township was located on Lake Saint Clair and the Clinton River, guests to the city often preferred to play and to take their rest on the waterfront.

The final chapter is an effort to recreate the atmosphere of the Bath City. Many businesses existed primarily because of the huge influx of visitors, especially in the summer months. Unfortunately, cards were not available for many of the entertainers who made Mount Clemens their home or just stopped by to bathe in its waters.

One
BATH HOUSES AND RELATED HOTELS

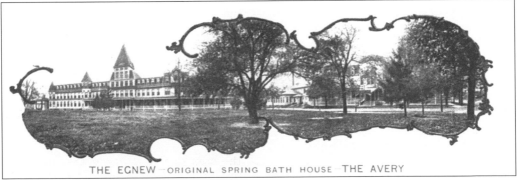

THE EGNEW—ORIGINAL SPRING BATH HOUSE—THE AVERY

The first bath house, appropriately named the Original, was built in 1873 on the corner of Jones and Water Streets. Around 1884, it was connected to the Osborne, later known as the Egnew, Hotel and the Avery House by enclosed, heated passageways. When the Original burned to the ground in August of 1883, it was rebuilt and reopened in January 1884.

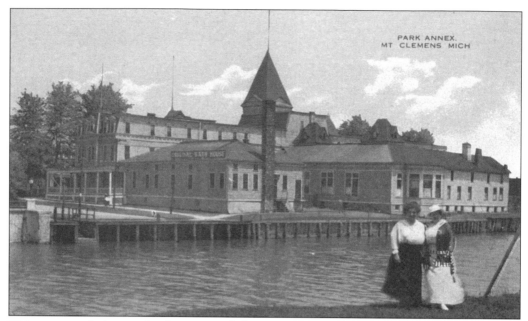

This postcard shows the location of the Original Bath House on the banks of the Clinton River. For nearly a decade it was the only bath house in town. It was financed by contributions from the local citizens. The site has been given back to the citizens, and is now called McArthur Park. Baths cost 50¢ plus 25¢ for an attendant.

The Avery House was the first hotel created specifically for the purpose of accommodating guests for the city's first bath houses. Built around 1880, it could accommodate 400 guests. In 1893, the *Cutter's Guide* praised hotel proprietor E.R. Egnew. "In all our travels, we have never found a better landlord." Unfortunately, in 1906 the Avery was the first of many hotels to be destroyed by fire.

Built in 1894 as an addition to the old Osborne Hotel, which had previously been the Kendrick, the Egnew was in for a few changes, too. It was known as the Annex, the Park Annex, the Riverside, and in later years as Clinton Gables. Despite the beauty of the building and its setting, one mother just wanted to go home. She wrote, "My dear little daughter, I hope this finds you well. I am so homesick tonight for you all. I wish the 3 weeks was up so I can come home. When I see the children go home from school that is when I get homesick for you and your sister. Take good care of my plants." The above postcard shows the Annex and the passage to the Original Bath House. Below is the Riverside.

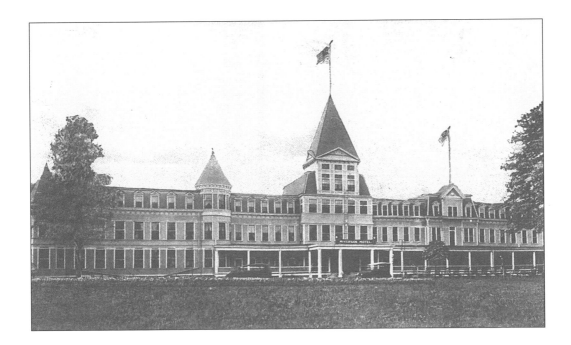

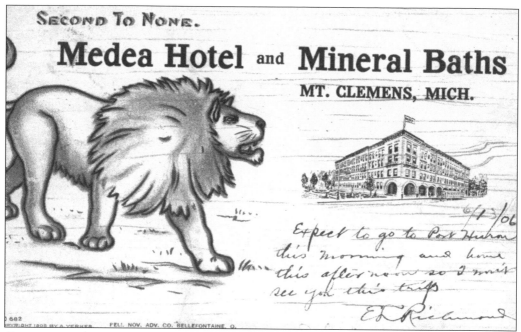

Contrary to the message on this postcard, the Medea Bath House, built in 1882, was the second Mount Clemens bath house. It was built by the Mount Clemens Bath Company at 19 South Gratiot near Cass. The 150-room hotel wasn't added until 1904. It was named after Medea of Greek mythology who possessed the power to heal.

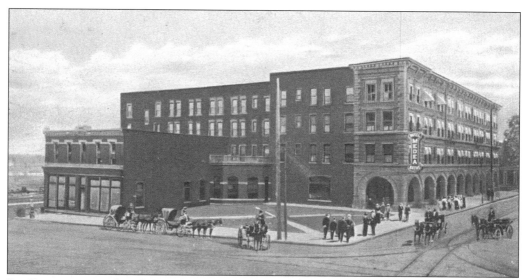

Business was good in the early years and increased steadily. The number of baths given in the month of July at the Medea soared from 4,869 in 1890, to 6,748 in 1891, and 7,681 in 1892. Luckily, the bath house had been rebuilt in 1891, with 150 tubs, making it one of the largest bathing establishments in the world. It had the capacity to give 1,500 baths a day.

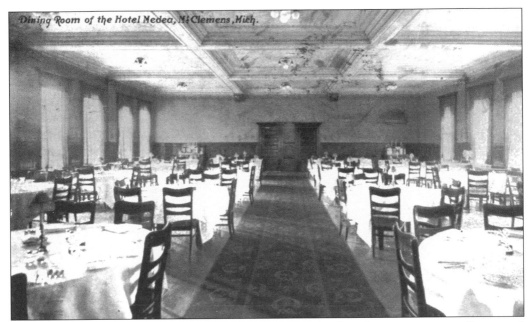

Dining Room of the Hotel Medea, Mt. Clemens, Mich.

Local historian Robert Eldredge described the Medea dining room as "a grand apartment." Perhaps that is one of the reasons why the Medea became a meeting place and activity center for local society. The hotel also featured a buffet and grill in a detached building.

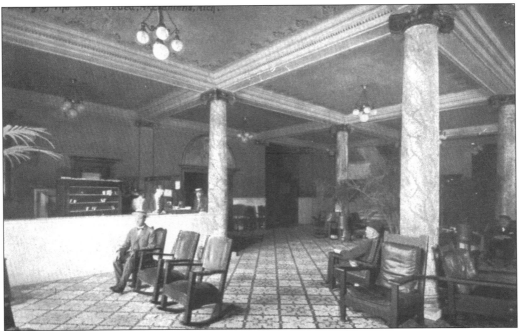

The Medea lobby was resplendent in white marble with marble pillars and stairway. Visitors during the bath era were greeted here by three generations of the Ullrich family. When Paul and Adam Ullrich decided to invest in the bath house, they could not have known that Paul's son and grandson would make it a family tradition.

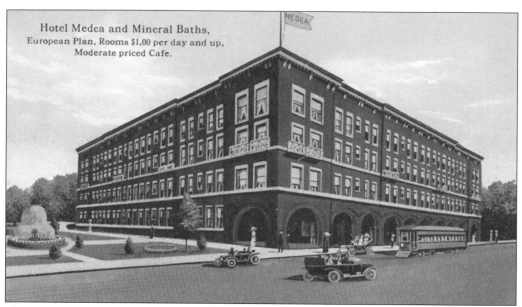

Hotel Medea and Mineral Baths.
European Plan, Rooms $1.00 per day and up.
Moderate priced Cafe.

This postcard is fascinating since it features a Medea that never existed. According to local historian Norm Lorway, who led an unsuccessful campaign to save the Medea when it was scheduled for demolition in the late 1980s, this was what the addition to the Medea was supposed to look like. This postcard company apparently wanted to be one step ahead of the rest.

Like many small hotels that sprung up close to the bath houses, the Lexington, located next to the Medea, was also connected to the bath house. It accommodated 75 visitors at a rate of $10 per week. David P. Wappner was the proprietor. Many visitors preferred the small hotels for their home-like atmosphere.

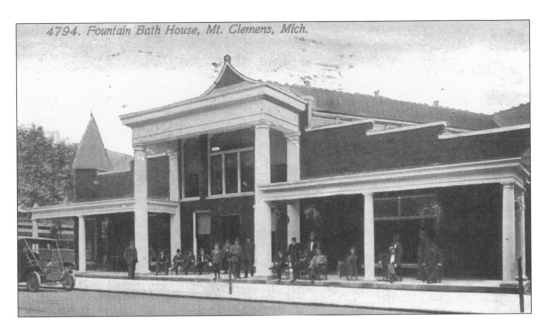

4794. Fountain Bath House, Mt. Clemens, Mich.

The Fountain Bath House, built in 1886, was the third in the city. It was constructed by Charles H. Meldrum, who came to find relief for his health problems and stayed to create a business for his sons. The Fountain was well-ventilated, had larger than average tubs for the severely handicapped, and provided a gymnasium. Its real claim to fame, however, came in 1888 with the installation of electric lights, the city's first. An electric generator was used to power the lights. Unfortunately, the next notoriety came when its derrick fell into the street in 1913. The water that escaped was so potent that wood in the area was destroyed.

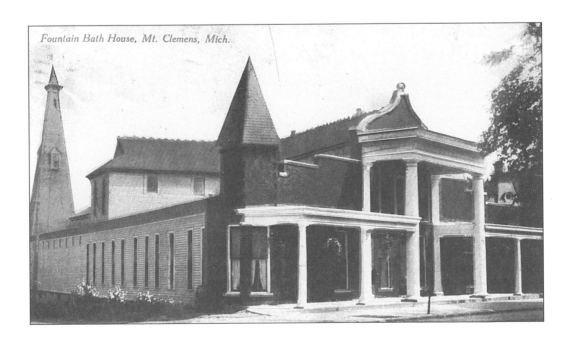

Fountain Bath House, Mt. Clemens, Mich.

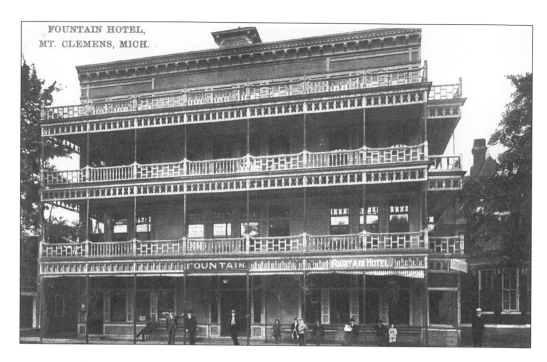

One year after the bath house opened, the Fountain Hotel was built. It was four stories high and boasted its own first—the only elevator in town. The hotel was located at 124 North Gratiot. The bath house was located at 118 North Gratiot. Since the Crystal House and Clinton Street came between, a heated, underground passageway was built to connect the two. On New Year's Eve of 1924, while the hotel was closed for the winter, a spectacular fire destroyed the Fountain and badly damaged the Crystal House, which by then was called the White Star Hotel.

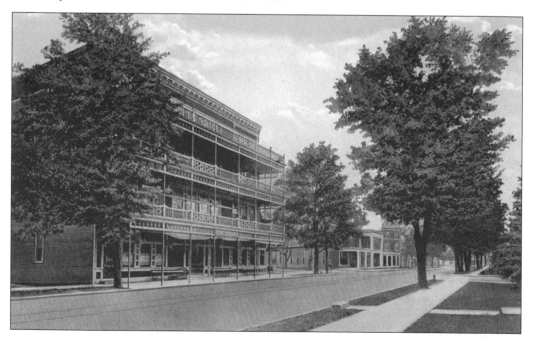

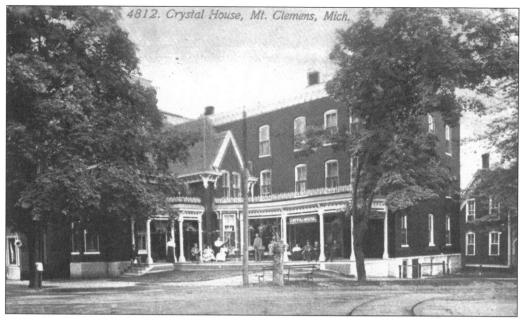

The Crystal House was located on the corner of Gratiot and Clinton Street. Cutter described the parlors when he wrote that they were "as cozy, homelike and prettily decorated as those of most private dwellings, and the guests are made comfortable, whether invalid bather or of the healthy transient public."

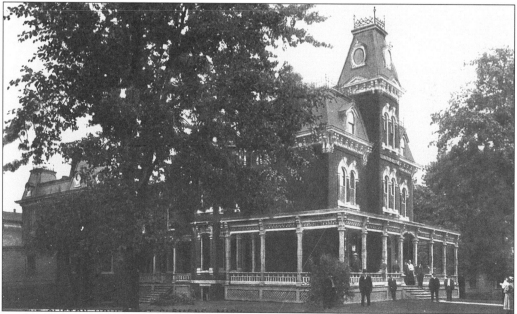

According to Cutter, "This house has one of the most commanding and sightly positions in the city, facing one of the numerous flat-iron-shaped city parks, and just beyond the business part of the city on the corner of North Gratiot Avenue and Market Street." Originally built as a residence, it was converted in 1879. The Clifton could accommodate 75 guests.

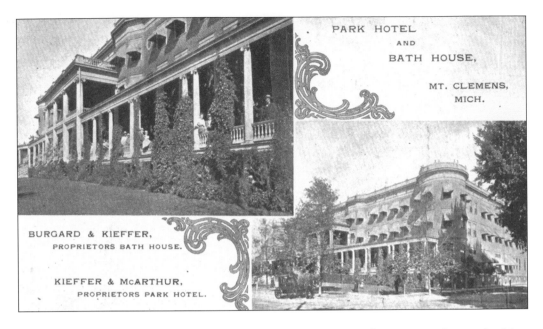

PARK HOTEL
AND
BATH HOUSE,
MT. CLEMENS,
MICH.

BURGARD & KIEFFER,
PROPRIETORS BATH HOUSE.

KIEFFER & McARTHUR,
PROPRIETORS PARK HOTEL.

The fourth bath house was built by another out-of-towner who came to the city looking for a miracle. Margretha Kieffer was hoping, when she left her home in Buffalo, New York, that the "cure" would be the answer to her daughter's desperate medical problems. Despite the fact that her daughter was not saved, Mrs. Kieffer believed in the power of the water. She and her husband purchased the Central Park Hotel at 61 East Street, refurbished it in 1891, added the bath house in 1892, and enlarged the hotel in 1897. In the process, they created one of the most famous and outstanding hotels in the country. The Park was razed in 1940.

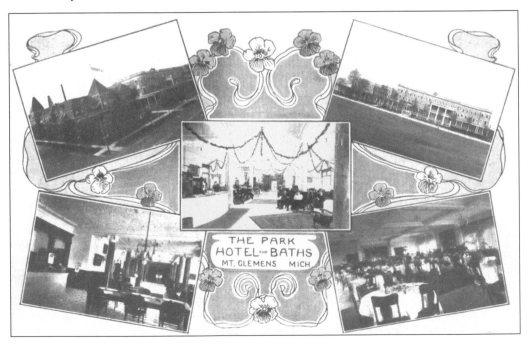

THE PARK
HOTEL AND BATHS
MT. CLEMENS MICH.

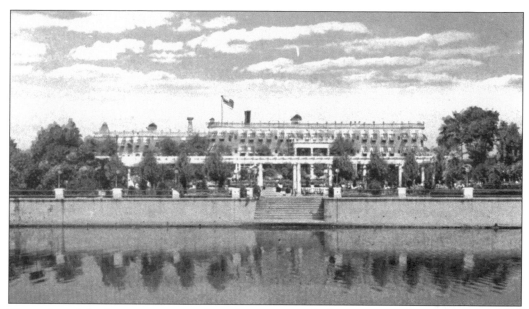

The mineral baths were potent, but the cure needed one more element, relaxation. What could be more calming than this scene with the trees reflecting in the tranquil water? The Nellis newspaper's *Pageant of Progress* edition said, "There is an atmosphere about the Park Hotel that has individuality in it. You will hardly find anything just like it elsewhere. The tense pre-occupation of hurried living is entirely lacking."

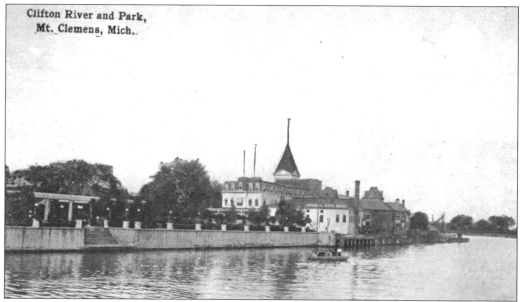

Clifton River and Park, Mt. Clemens, Mich.

As is obvious in this postcard, from the proximity of the Original to the Park, competition was fierce in the Bath City. Atmosphere is always important, but results are what count. If the mineral baths and massage were not the key to better health, the Park had other remedies to offer. Visitors could receive high colonic irrigation, diathermia, Morris waves, nauheim baths, and other treatments.

The Park Hotel and Bath House, all under one roof for convenience, was the largest and most famous of the city's spas. It was, of course, also the most expensive. Fannie Hurst, Helena Rubenstein, Jerome Kern, William Jennings Bryan, Mae West, Booth Tarkington, Alice Roosevelt, George M. Cohan, William Randolph Hearst, and Henry Ford were among the celebrities who chose the Park, perhaps as much for its elegant

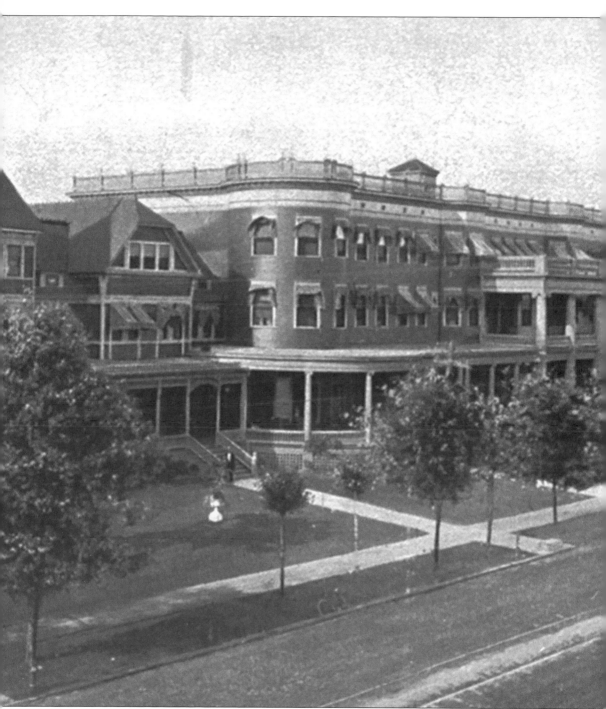

atmosphere as for its bathing facility. According to the *Pageant of Progress*, "It is alleged that some of the best golf and fish stories in the country had their origin on the porch of the Park Hotel." From these postcards, it is easy to see that there was plenty of room on the porches for the largest of tall tales.

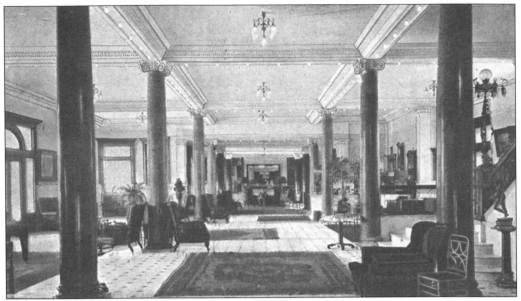

"Inside one finds magnificent lobbies with spacious appointments to meet the most exacting desire. Cheerful attendants give service." The words of the *Pageant* of *Progress* can be verified by the stately columns, classic rugs, and comfortable chairs seen here in this *c.* 1912 postcard. The ornate ceiling and arched windows speak of the class of the hotel and the people who frequented it.

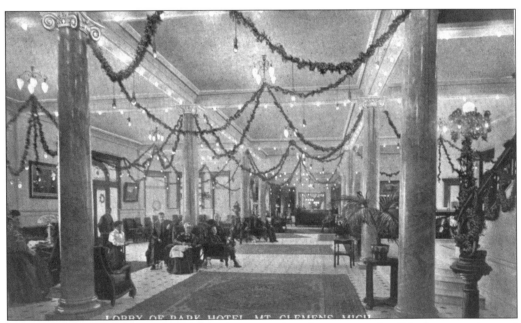

The scene is set in this postcard for Christmas, but there were also fabulous parties and balls held to celebrate every imaginable occasion. The Park was known as the social center of Mount Clemens, primarily for the city's elite. The story told by Mrs. Elizabeth Grant was of a Dutch garden party. It cost $5,000 to create gardens for the gala event.

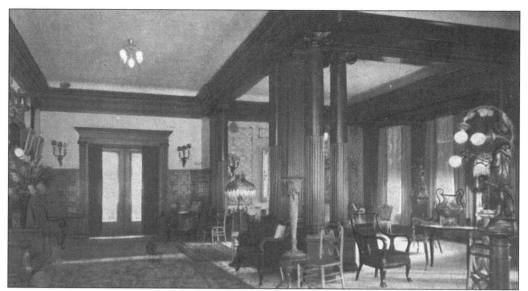

Elegance was a must at the Park, and its parlors were no exception. According to the *Pageant of Progress*, "Its luxurious parlors have been visited by famous persons from all over the country and abroad, parlors that display one of the finest art collections of any hotel in this country." The collections were obtained by Mrs. McArthur at the World's Exposition in Paris in 1900.

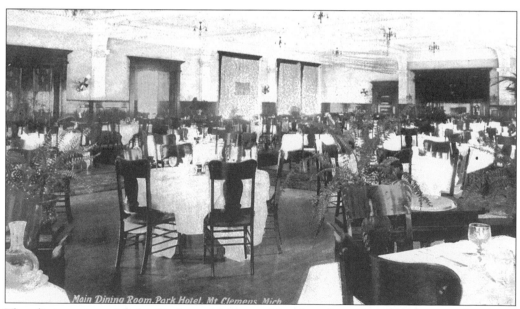

The dining room of the Park could be nothing but first class. In the words of the *Pageant of Progress*, "The cuisine of the Park Hotel is maintained at an exceptionally high standard. Appetizing dishes, including always a generous choice of fresh vegetables, fowl, fresh fruit, are planned by an expert dietitian. Special attention is paid to dietary menus prescribed by house or home physicians." The room accommodated 350 guests.

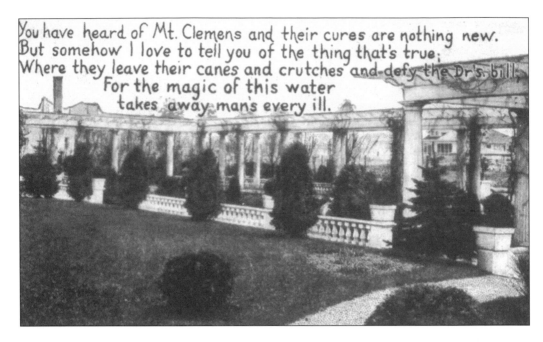

You have heard of Mt. Clemens and their cures are nothing new.
But somehow I love to tell you of the thing that's true;
Where they leave their canes and crutches and defy the Dr's bill,
 For the magic of this water
 takes away man's every ill.

The *Pageant of Progress* said it well. "The Park's garden is like Eden. . . Swept by the refreshing breezes of Lake St. Clair, the Park Hotel gardens afford a keen pleasure to guests. Along the sunny terrace facing the Clinton River are rows of comfortable seats for sun bathers, and many secluded nooks invite rest and relaxation." The "terrace" referred to here was probably the Park Pergola. It was a bit too far inland from the lake to be swept by its breezes, but it was certainly a lovely setting for recuperation. The park was actually across the street from the hotel and bath house. It was created on the site of the Avery House following the fire that destroyed the hotel. It was first called Margretha Park, but is now known as McArthur Park.

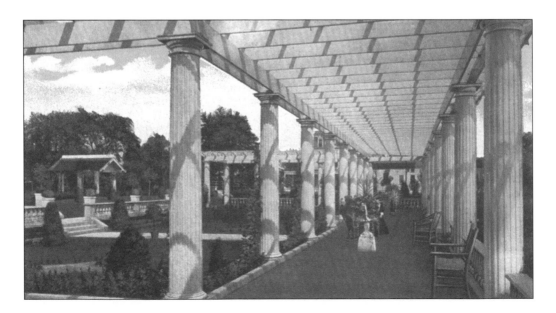

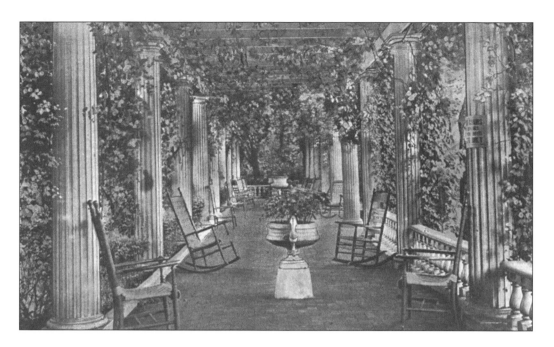

The *Pageant of Progress* describes the Park Hotel grounds in words that beg to be quoted. "A lazy walk thru shaded paths of a spacious garden, paths leading to winding streams, to old world flower patches, to quaint retreats of nature, paths so completely removed from the work-a-day world as to lure the busiest capitalist from the most engaging task. A perfect complement to nature's health treatment are the delightful gardens of the Park Hotel. Here one may sit in sunshine or shade—here one may view the pleasure craft plying the sleepy Clinton. Above, the birds sing—how restful—exactly what Park guests have been traveling miles to find. Such old world calm and peaceful atmosphere is indeed rare within 20 miles of one of the most industrial American cities."

View near Boat Landing in the Park,
Mt. Clemens, Mich.

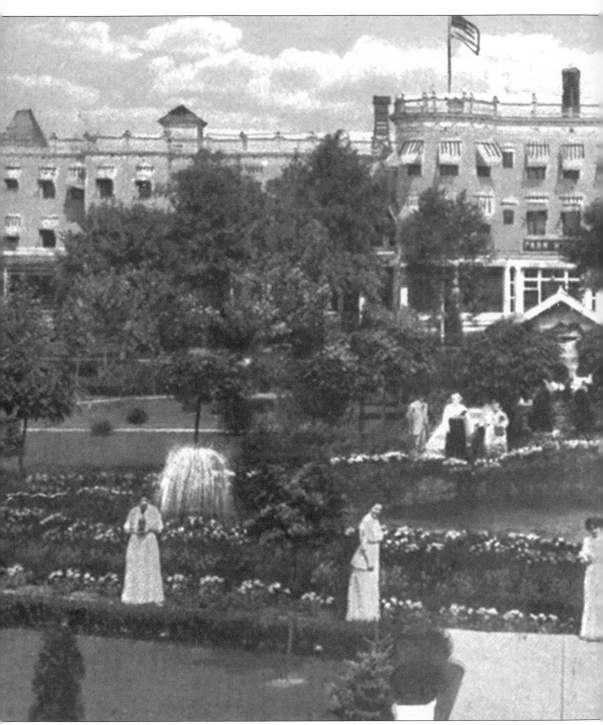

The message on this card says a lot about life in the Bath City far away from home. It also shows how false information can be easily passed on. The city had 11 bath houses and 78 hotels during its peak seasons. "Dear Hubby just a card to say I am ok had my bath did not mind today went with Mrs. C to the bijou last night about one block from

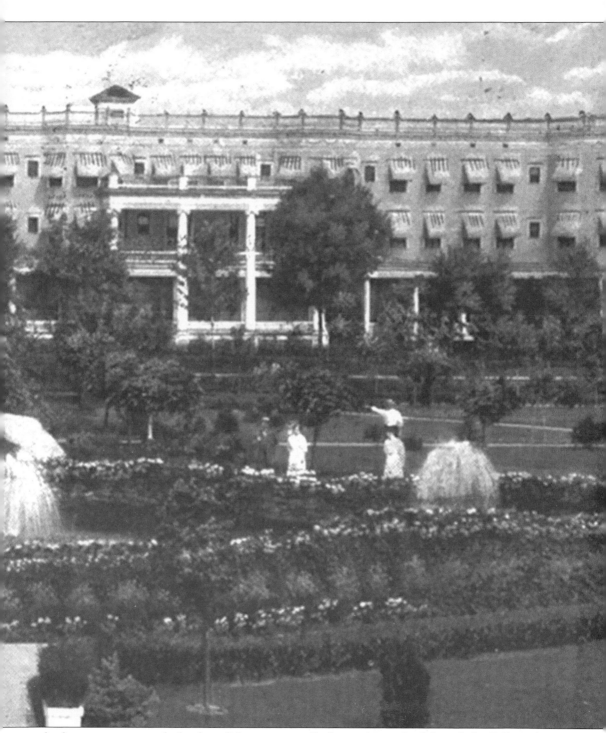

the house was a good play but did not rest well after going to bed found the P.O. today this is some town heard a man say last night there was 140 bath houses and hotels will write you a little Thursday everything is fine by by LMH."

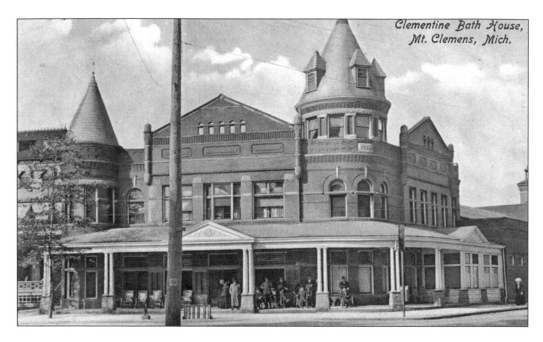

Clementine Bath House,
Mt. Clemens, Mich.

B.B. Coursin built the Clementine Bath House in 1892. On the corner of Cass Avenue and Walnut Street, it was the fifth Mount Clemens bath house. Coursin was another visitor who found so much improvement in his health from the baths that he built his own bath house. In 1911, a second well was added which proved beneficial in the peak years of the bath era. Not only did the Clementine not run out of water, but it often provided additional water for the bath houses with only one well. Coursin was also responsible for the building of the Eastman Hotel. He sold the Clementine to a fellow Pennsylvanian, John R. Murphy, in 1904. Murphy also came to Mount Clemens for the baths.

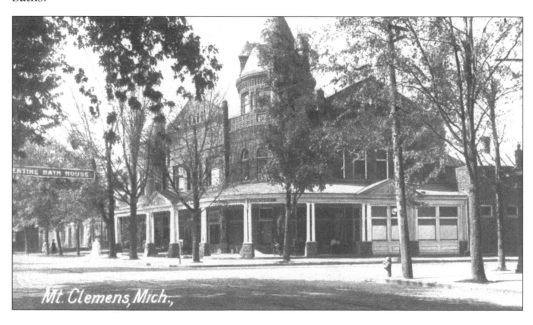

Mt. Clemens, Mich.,

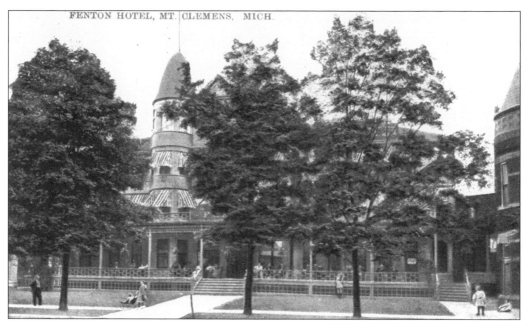

FENTON HOTEL, MT. CLEMENS, MICH.

The Fenton Hotel was just west of the Clementine and was built by George C. Fenton in 1892. It was directly connected to the Clementine, and later to the Olympia as well. It was popular as a local meeting place. In 1910, it was purchased by the Olympia Hotel Company, completely remodeled, and renamed the Olympia Hotel.

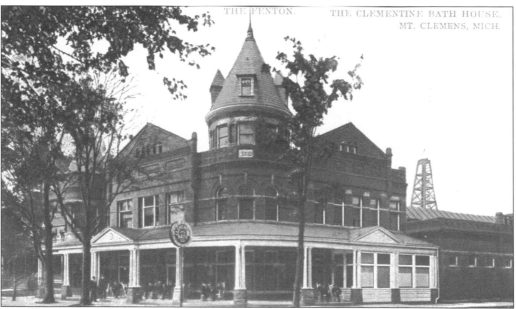

Despite the fact that this postcard is labeled the Fenton, this building, according to local historians, would not be called by that name until after John R. Murphy added two stories to it in 1914. At that time, George Fenton, who had sold his hotel next door, leased the top two floors from Murphy. The derrick can be seen behind the Clementine Hotel. The buildings were demolished in 1973.

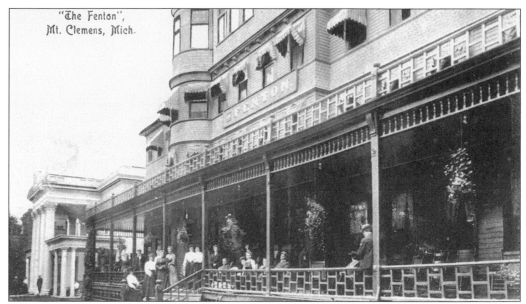

"The Fenton", Mt. Clemens, Mich.

This postcard shows the Fenton in relation to the Olympia Bath House. It is easy to see why the Olympia owners looked to the Fenton for hotel space despite the fact that it was already connected to the Clementine. These types of mergers, especially since the top of the Clementine was later to be called the Fenton, must have been as confusing for visitors as they are for today's historians.

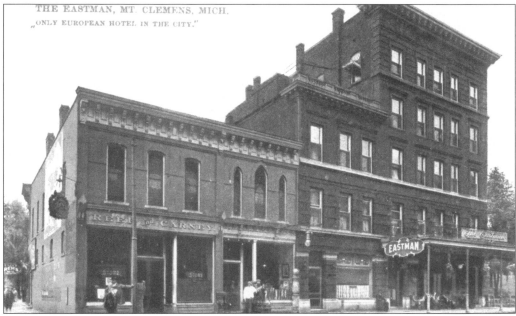

THE EASTMAN, MT. CLEMENS, MICH.
"ONLY EUROPEAN HOTEL IN THE CITY."

The Eastman Hotel was opened in 1900 at 49 Cass. At that time, it was the tallest building in the city, an astounding five stories. It was believed to be essentially fire-proof. It was convenient to the business district as well as the bath houses. Shortly after the death of her husband, Nellie Metler Murphy purchased the Eastman and renamed it the John R. Murphy Hotel.

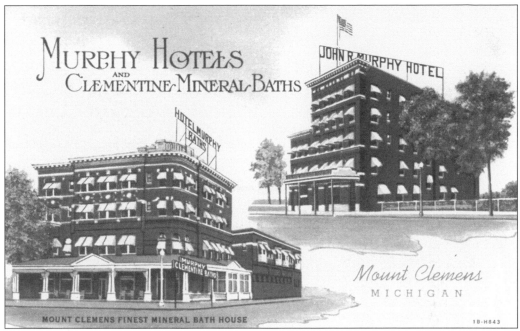

This postcard shows both buildings; the Clementine Bath House with the two extra stories, and the John R. Murphy, originally the Eastman. In 1946, the Clementine Bath House and Hotel, along with the John R. Murphy Hotel, were sold to Frank Rich of Baltimore, Maryland. He was another visitor to the Bath City who stayed to become part of the bath industry. He renamed them the Murphy-Clementine Baths.

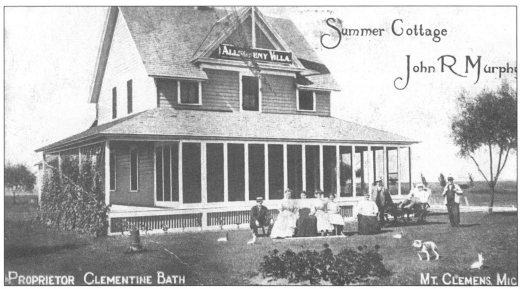

This was the summer home of John R. Murphy. With his winter home just a few miles down the river, it seems strange that anyone would need a second house so close to the first. In the summer, however, the city was hot and crowded. At the mouth of the river, the lake breeze and the solitude were a refreshing change. The rabbits were manufactured by Donaldson Brothers in town.

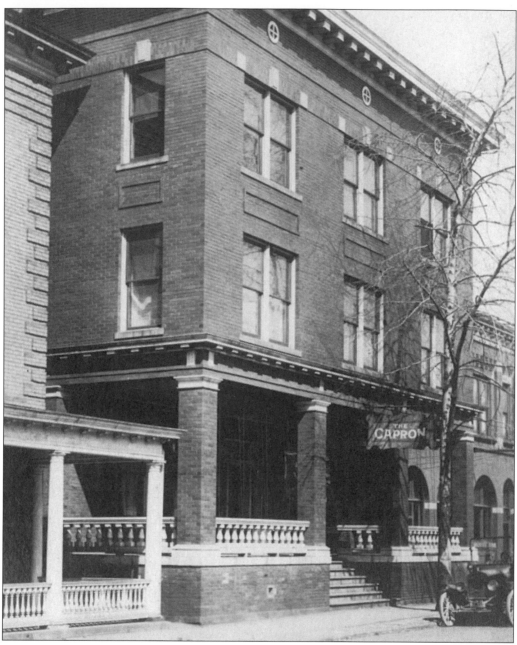

The Capron, called "well arranged, comfortable, and tidy" by Cutter, was located at 19 North Walnut Street. A few doors from and directly connected to the Clementine, it was also only a block from the Medea. The Capron, built in 1899, had 20 guest rooms, but that number had moved to 44 by the 1930s. According to the *Pageant of Progress*, the hotel was "always owned by the Capron family," and Mrs. Capron was known to "furnish an excellent table service." Of course, Mrs. Capron could not go on forever. By 1948 the name had been changed to the Hotel Adaskin, and in the 1950s it went under the name Hotel Manor. The house was demolished around 1960, like buildings before and after, to make more space for parking.

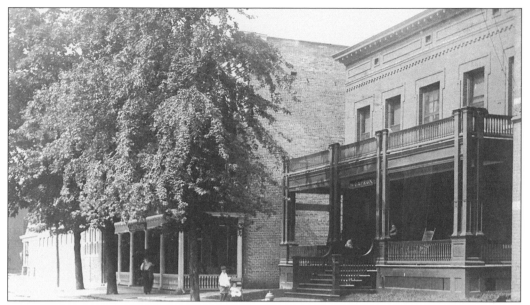

The *Pageant of Progress* found the Capron convenient and modestly priced. "An effort is made at the Capron to make the stay of the guest as pleasant as possible, and many forms of entertainment are provided. The rooms are large and well ventilated, and are comparatively cool even during the hottest summer days."

The Capron was close to town, connected to a bathhouse, and a friendly place to stay. People came back year after year. The *Pageant of Progress* called that "a testament to the desirability of the hotel." It was, but repeat guests were common in the Bath City. One visitor claimed he had been coming to Mount Clemens for 104 years. Perhaps that was a bit of an exaggeration.

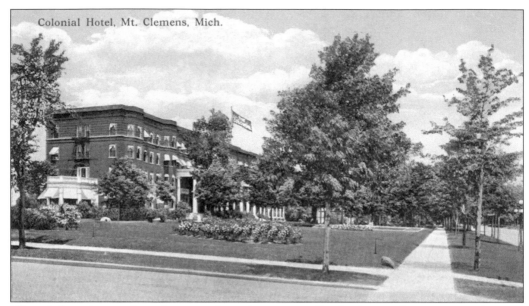

Colonial Hotel, Mt. Clemens, Mich.

The Colonial Hotel and Mineral Baths, originally built as the Mount Clemens Sanitarium, became the sixth bath house in 1896. The name was changed in 1897 to reflect the style of the red brick building. The hotel was located at 234 South Gratiot atop the highest ground in the city.

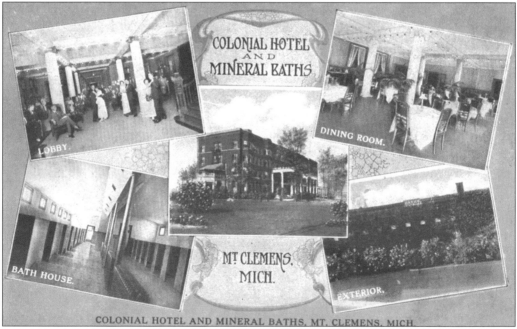

COLONIAL HOTEL AND MINERAL BATHS, MT. CLEMENS, MICH.

The Lilly sisters, Emma and Ida, of Indianapolis, must have been impressed with their visit. They, together with Dr. A.N. Shotwell, were responsible for the building of the Colonial. Shotwell became the first medical director. In 1901, E.R. Egnew took over as manager. This was a few years after his Original, Avery, and Egnew were sold to the Original Bath and Hotel Company.

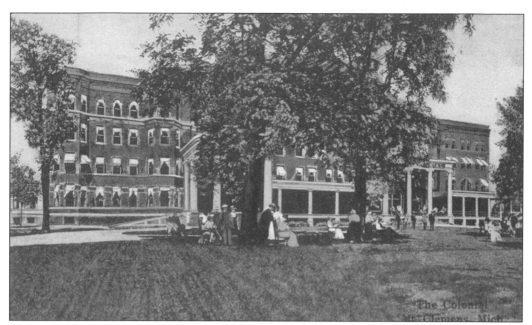

In her honeymoon memoirs, Mary Vincent Cummings wrote, "We decided about a week before that we would be married that Saturday, but we hadn't decided where so we looked over all the surrounding County Seats where we could possibly be married, and chose Mount Clemens because we could stay at the wonderful Colonial Hotel. . . making a delightful beginning for our lifetime honeymoon." What hotel could ask for a better testimonial?

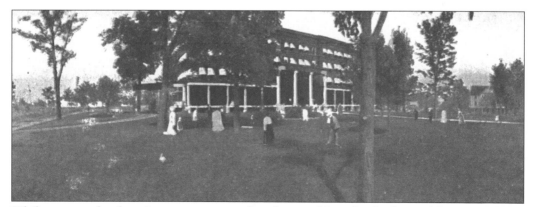

While rest and relaxation were musts for those taking the baths, mild exercise was recommended also. The Colonial, with its extensive lawns, featured a small golf course and croquet grounds. Even on rainy days, the Colonial porch was long enough to allow for a brisk walk. For those less inclined to exertion, the basement contained a billiards room.

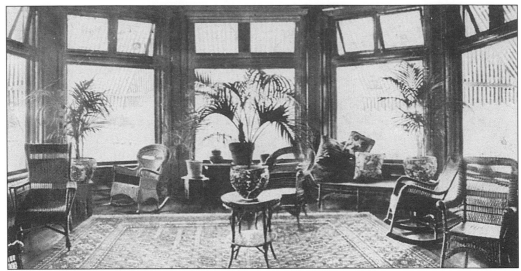

Since hotels became a home away from home for the bathers, an important accommodation was the parlor. The sun parlor, women's parlor, and writing room provided a quiet place to read or write letters, an opportunity to make new friends, or simply a get-away from the confines of one's hotel room. The Colonial's sun room provided an excellent view of the front lawn, golf course, and croquet grounds.

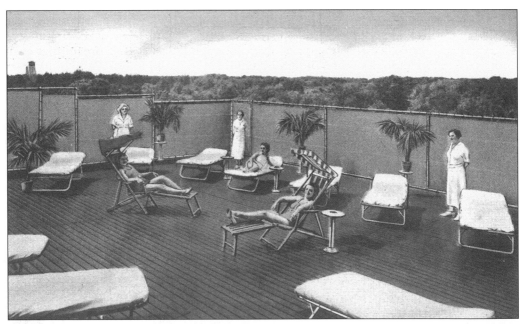

Another added feature of the Colonial was the roof-top solarium. If the goal of the bath was to open the pores and let the built-up toxins out, basking in the sun was an extension of the treatment. Today many massage therapists advise a soak in the sun following a treatment. Unlike the bathers here, however, today's patients would be warned to drink a lot of water and use sunscreen.

Dr. Gustaf A. Persson took control of the Colonial in the late 1920s. Persson had planned to build an elaborate new bath house and research facility to be named Perssondale. The *Pageant of Progress* devoted two pages to pictures and text describing the undertaking. Unfortunately, the pictures were only artist's renditions, and the text extolled a haven never to be built. After abandoning the project, Persson had to be content with the typical bath house, much like the one pictured below. He did, however, create a foundation to operate the Colonial and carry on research in the hope of finding a cure for rheumatism. That was apparently another dream that went unfulfilled. The Colonial burned in May of 1984.

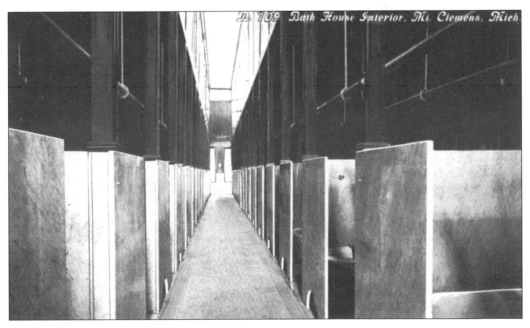

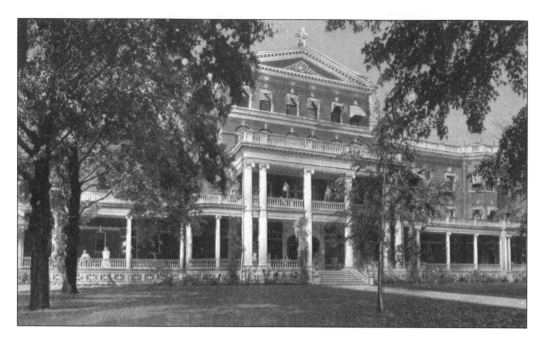

The Saint Joseph Sanitarium and Bath House was built in 1899 by the Sisters of Charity of Saint Joseph, Cincinnati, Ohio, after one of their own received treatment in the Bath City. The bath house was located at 215 North Avenue, away from the traffic of the city. In 1900, the sisters converted the third floor to a 50-bed hospital. By 1952 the baths were gone, but the hospital remained, known today as Saint Joseph Mercy Hospital East. As of December 1998, patients were again welcomed to come and bathe in the restorative waters. Only time will tell whether a new bath era is on the way.

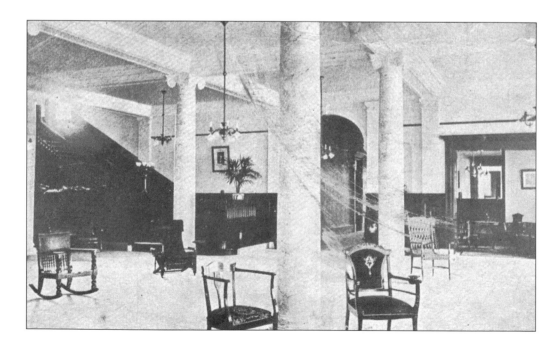

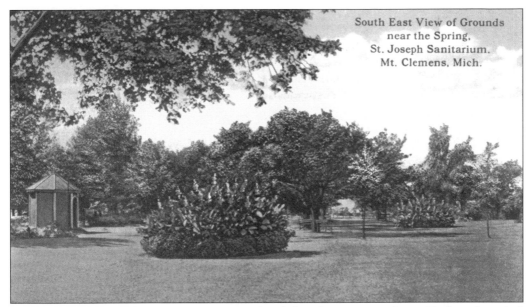

South East View of Grounds near the Spring. St. Joseph Sanitarium. Mt. Clemens, Mich.

In the early days, there was extensive land for fragrant gardens. Today, hospital expansion and parking demands have eaten away at the space set aside for quiet reflection. In 1986, Saint Joseph Hospital and Bath House was placed on the Michigan Register of Historical Places. Today it stands, the last remaining bath house, as a monument to a bygone era.

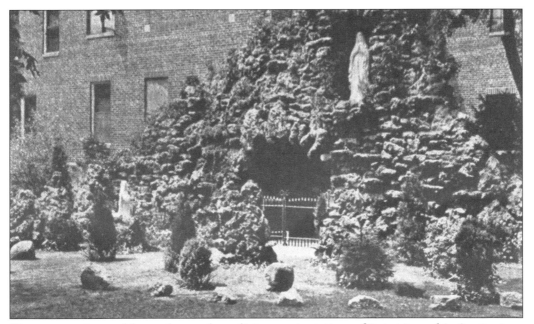

The grotto pictured here shows the religious orientation of Saint Joseph's Sanitarium and Bath House. On hand to bless the project at its dedication were Archbishop Eden of Cincinnati, Bishop Foley of Detroit, Bishop Burns of Nashville, Bishop Richter of Grand Rapids, and Bishop Moss of Covington, Kentucky. Perhaps these blessings account for the hospital's longevity and status as the last remaining bath house.

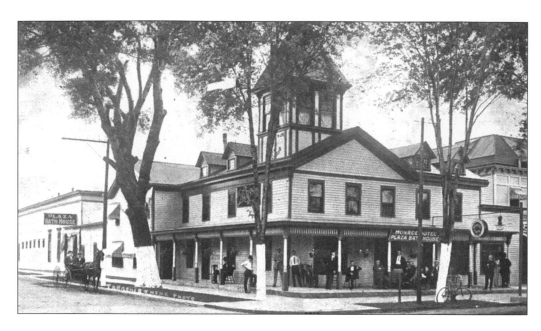

The Plaza Bath House, number eight, was erected around 1901 at 34 Jones Street. It took the place of the Monroe Garden, formerly a feature of the Monroe Hotel. Originally the Plaza was a family affair. Julia Miller, who grew up in the family business, was quoted in the *Pageant of Progress*. "My faith in the bath industry has been built upon one fact—the cure of rheumatism. For that one ailment there is nothing anywhere in the world to equal the curative power of the Mount Clemens mineral water." Although she called it a cure, she did everything in her power to insure that her guests returned to the Plaza rather than another bath house. Whenever she could spare the time, she even read to her invalid guests.

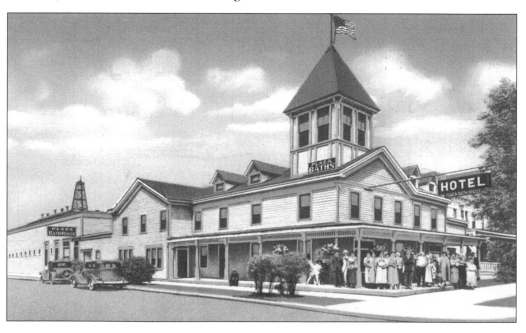

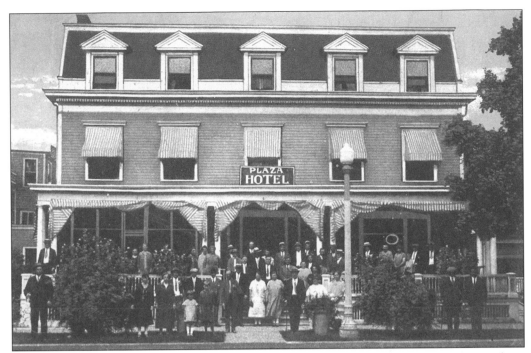

The Plaza Hotel was built in 1912 by Herman Miller and his sons. It was located on what was known as Hotel Square. While it was connected by a hallway to the Plaza Bath House, it was also close to the Original and the Park. As well as catering to bathers, it was considered a family hotel. The Millers even raised their own vegetables and poultry on a farm nearby.

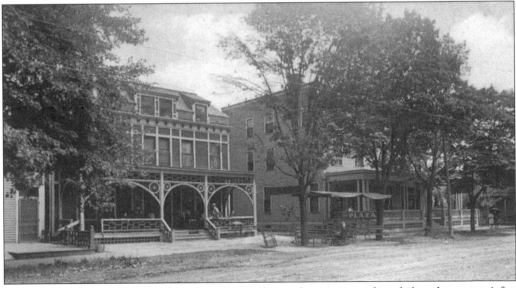

According to Cutter, "This hotel is situated in what is considered 'headquarters' for hotels and bath houses, having for neighbors, upon the same or adjoining blocks, the Park, the Avery and Annex Hotels, and the Original, Park and Plaza Bath Houses." The villa was connected to the Plaza by a covered, heated passageway.

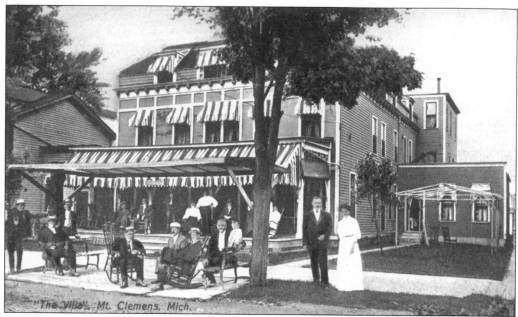

According to the 1897 publication *Headlights*, the Villa was "one of the most complete and home-like hotels in the city. . . first-class in every respect; can accommodate sixty guests and is supplied with steam heat, electric light, and all those modern conveniences that go to make up a well appointed house." It was located opposite the Original Bath House.

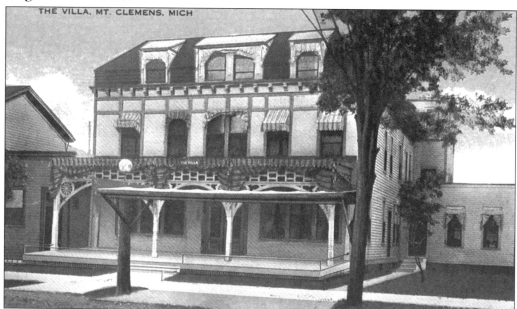

Obviously the guest who sent this card was more than satisfied. She wrote, "I am feeling much better. My lameness is almost all gone. Just a little stiff. My cold or grippe is better, my cough is better. I rub my chest with musterole and put a cold wet towel round my throat at night and am going to take a walk this afternoon. Have not been out much."

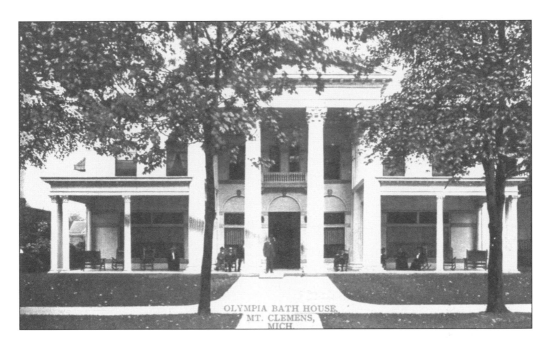

OLYMPIA BATH HOUSE,
MT. CLEMENS,
MICH.

The elegant white pillars of the Olympia were in stark contrast to the brown brick of the neighboring Olympia Hotel. The bath house was opened in 1903 at 84 Cass, adjacent to the Fenton Hotel. In 1910, the Fenton was remodeled and became the Olympia Hotel. Samuel Elkin, who with his sons purchased the Olympia in 1935, was one of the many bathers who came for the baths in a wheelchair and stayed. Sam and his son, Joe, were devoted to the idea of personal service. According to the *Pageant of Progress*, "From the time the visitor arrives at the door until he leaves. . . he is made to feel at ease. In addition to curing him, the Olympia wants the guest to enjoy his vacation, and that, incidentally, is an important part of the cure."

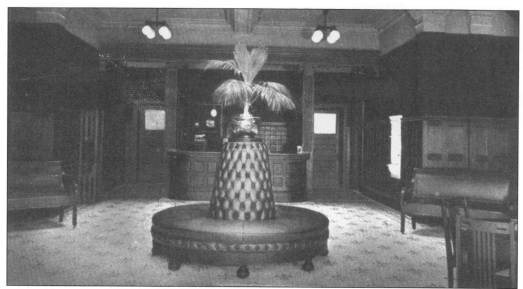

If nothing else, the lobby of the Olympia Bath House could certainly be called original. The *Pageant of Progress* said, "The lobby floor is devoted entirely to the comfort and amusement of the guest." The padded seats certainly were inviting. Unfortunately, the fate of the Olympia is an old story. It was torn down in 1955 to make room for a cold, hard parking lot.

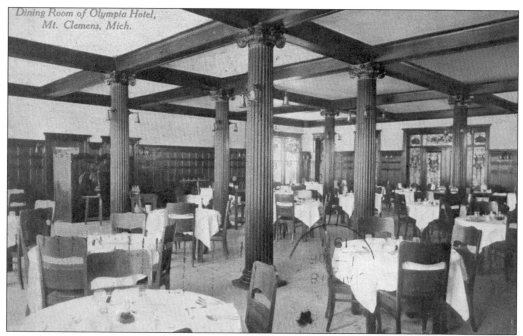

A headline in the *Pageant of Progress* reads, "Olympia Claims the 'Absolute' Dining Room." Cleanliness was the motto at the Olympia, and its dining room was no exception. The article goes on to say that, "The large columns of the dining hall lend a dignified atmosphere, yet there is a 'hominess' in the arrangement that will appeal to the smallest group." Of course, the excellent food was also mentioned.

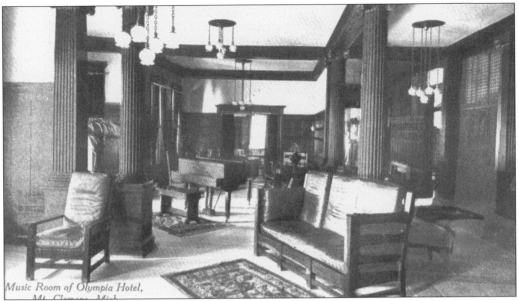

Music Room of Olympia Hotel, Mt. Clemens, Mich.

The *Pageant of Progress* went on to say, "The baths will not heal a broken heart, nor put a smile on a face which has never learned the art of smiling. They will not cure old age, though a few weeks here now and then will doubtless make the fullness of years more endurable." A few hours spent in this pleasant music room couldn't hurt, either.

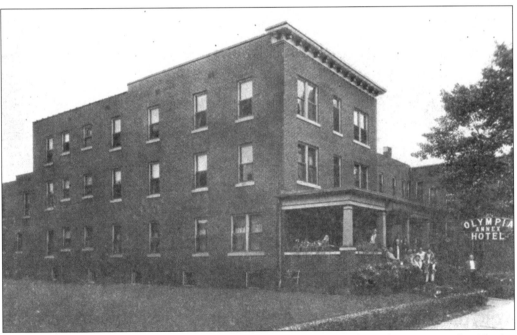

Another of the city's kosher hotels, the Olympia Annex was directly connected with the Olympia Bath House. The hotel had 33 rooms. The proprietor, Mrs. K. Gross, personally supervised the meal preparation. Hungarian food was featured. According to the *Pageant of Progress*, the Olympia Annex ". . . presents an inviting appearance to the guest inspecting the bedrooms, dining room, and kitchen."

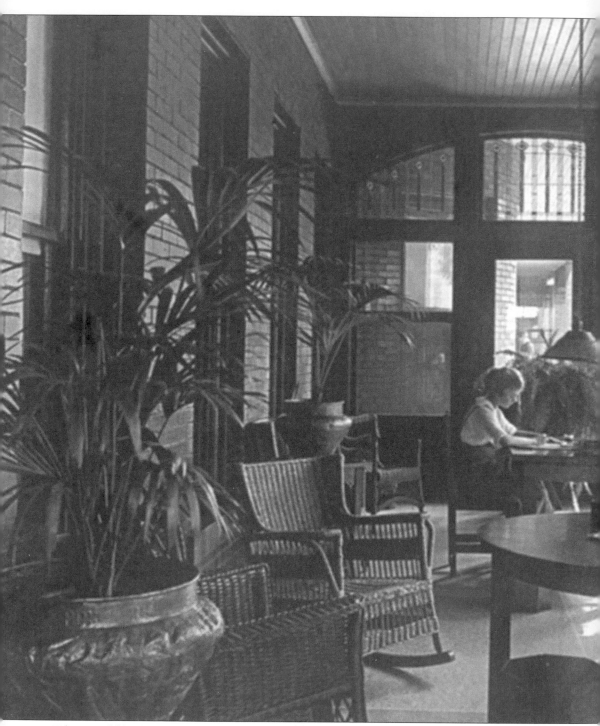

What could be more inviting and healing for the chronically ill than this sun porch? One of the additions when the Fenton was converted to the Olympia was this lovely room that looked out onto one of the most active streets in town. Here the weary traveler could read, write a letter, or just relax in the sunshine. Perhaps the man who wrote his

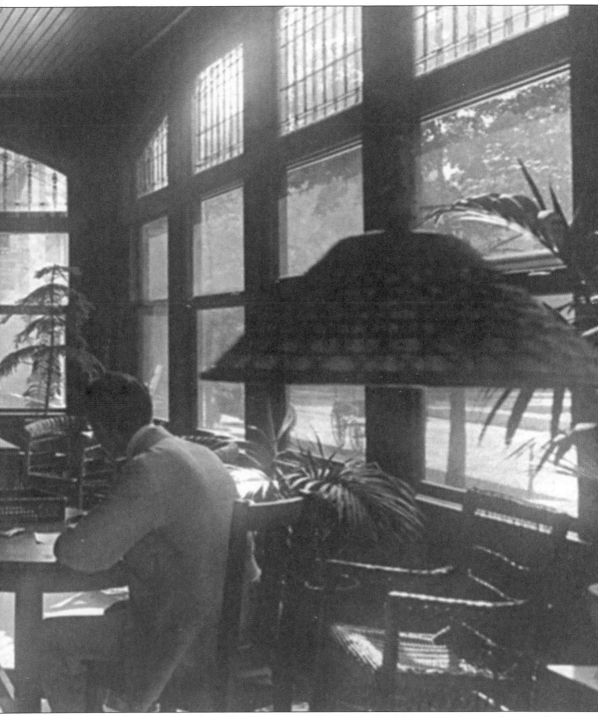

daughter sat in a place like this when he penned, "How's Daddy's Sweetheart? I missed not taking you to your dance lessons. Take good care of Mommy and Granny. Daddy has a surprise for you when I get home. Be careful when you ride your bike. Love and kisses, Daddy."

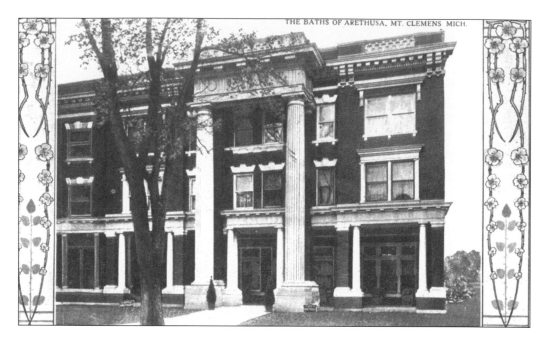

The last of the large bath houses to be pictured here, the Arethusa was built in 1910. It was located at 30 South Gratiot Avenue, near the Cass and Gratiot intersection. William Lehner, who as a boy of 16 worked at the Olympia Bath House, was asked to manage the endeavor after a disastrous first two years. One of the original backers, Lehner was able to keep the banks at bay until 1924, when the Feldman brothers took over. The Feldmans had, of course, come to Mount Clemens for the baths and decided to stay. Ironically, despite the early financial troubles, the Arethusa was the last bath house to discontinue the baths. In 1976, fire destroyed the building.

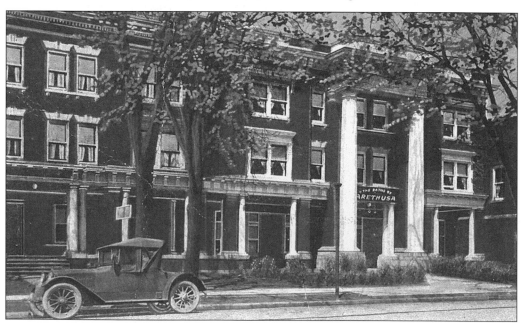

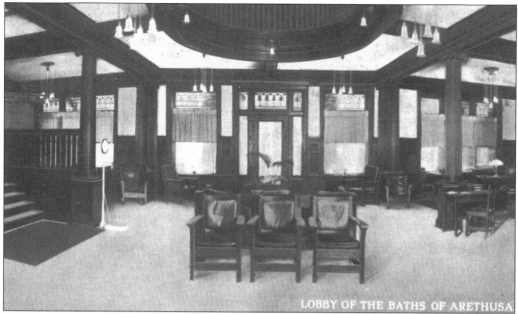

LOBBY OF THE BATHS OF ARETHUSA

The main lobby of the Arethusa was a meeting place for visitors from all parts of the country who returned each year for the cure and to get re-acquainted with old friends. It was furnished in mission oak with padded chairs for comfort. Since the bath house did not have adequate guest rooms, the Arethusa provided pick up and delivery services from local hotels.

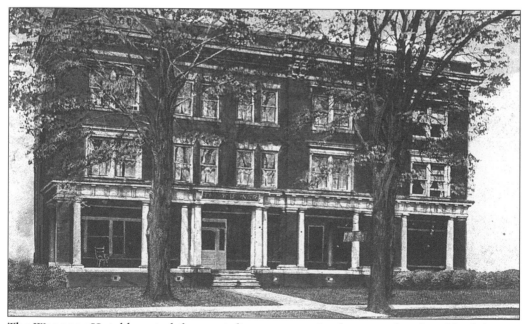

The Wappner Hotel boasted the most direct connection between hotel and bath house in the city. It adjoined the Arethusa Bath House and eventually became a part of the Arethusa Hotel. Built in 1908, its address was 34 South Gratiot. It was originally owned by the Wappner family but was sold to Leonard Kraemer in 1935.

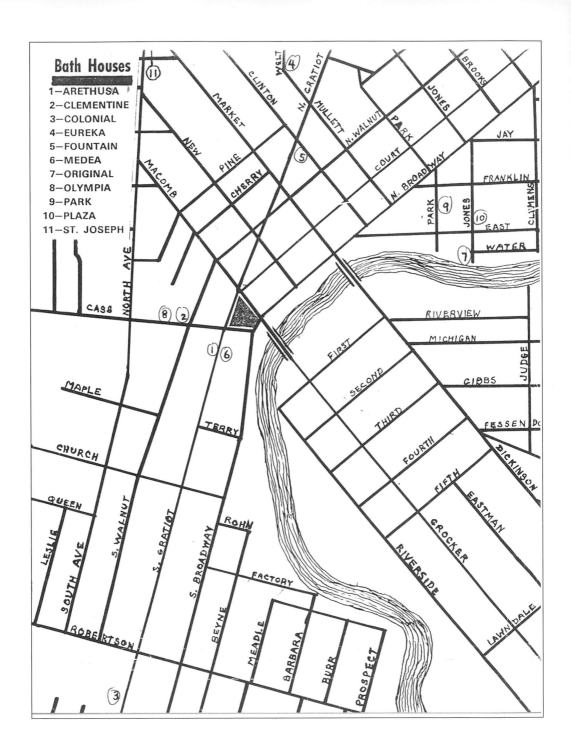

Bath Houses

1—ARETHUSA
2—CLEMENTINE
3—COLONIAL
4—EUREKA
5—FOUNTAIN
6—MEDEA
7—ORIGINAL
8—OLYMPIA
9—PARK
10—PLAZA
11—ST. JOSEPH

Two
BATH HOUSE HUMOR

According to the *Pageant of Progress*, "The oldest historical accounts of baths refer to them as of supernatural origin, and they were frequently believed to have supernatural healing powers." Moses had his River Jordan, and Homer liked to soak away his troubles in the Dead Sea. For the modern man of the late 1800s and early 1900s, however, there was the Bath City.

Once word got out that the baths really did work, crowds flocked to the city to get in line for the "cure." In 1927, it was estimated that 50,000 bathers visited the city during the months of June, July, and August. They came from South Africa, Australia, China, the West Indies, and other faraway places. Jack Dempsy, Henry Ford, and Eddie Cantor, who were said to have bathed at the Arethusa, were a few of the many visiting

These baths are great at Mt. Clemens

There cooking me out right here old Pall,

Herman

Although most patients were literally "cooked" in temperatures from 98–110 degrees Fahrenheit, others were given cool or tonic baths. Rheumatic ailments and skin conditions were treated in the hot baths. Patients with debility, paralysis, epilepsy, and insomnia, on the other hand, might be bathed in cooler water. Still others received alternating hot and cold water therapy.

celebrities. It was even rumored that the King of Siam chose Mount Clemens over the other famous spas. Perhaps he didn't like the city as well as others did, or the trip was just too long. He supposedly had the water shipped home. Although this was not recommended, surely nobody would blame him for not making an annual pilgrimage.

Quite the Style at Mt. Clemens

Style meant little to the sufferers who flocked to the city to be cured. While most of the major bath houses were connected to nearby hotels by heated passageways, many visitors stayed at the smaller hotels. Men and women in robe and slippers were a common sight on the streets of the city, especially in the early hours of the morning.

Fierce competition between hotels and bath houses led to the employment of "runners" to solicit business at the depot and on local boats. Runners were paid $1 for each new guest, so they would literally grab a new arrival's luggage and lead him to a hotel not of his own choosing. This practice did, at times, lead to brawls in the street, injury to the runner, and some very unhappy customers. An ordinance passed in 1905 did limit and control the runners' activities to some extent. They were required to be licensed, wear badges, and set up a stand.

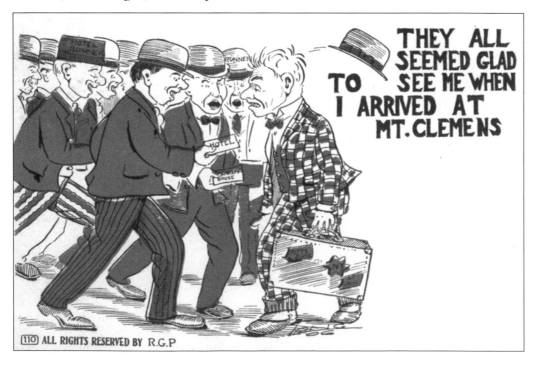

(110) ALL RIGHTS RESERVED BY R.G.P

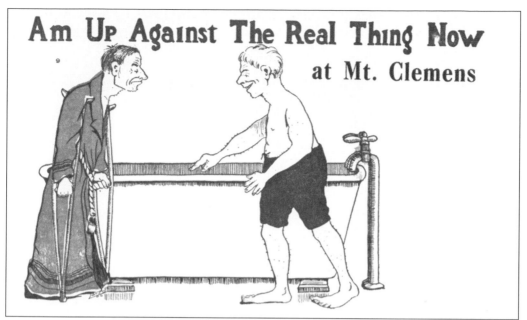

Mount Clemens water was the real thing, all right. According to John Meyer, a nationally known chemist who once analyzed the water, 65 gallons of mineral water contained 125 pounds of mineral solids including 30 different chemical constituents. An early newspaper article adds that one chemical may account for the superior healing qualities of the water—radium.

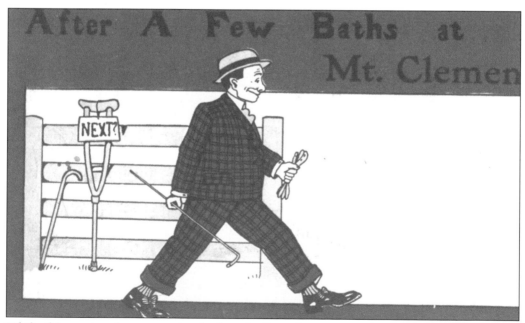

While this postcard seems to imply that the "cure" was miraculously fast, some patients found they needed more than the normal 21-bath treatment. It was impossible to predict whether the bather would throw away his crutches after three or four baths, or would have to persevere for six to nine months before achieving acceptable results.

Bathtubs used for mineral baths were oversized, but not as large as this postcard implies. Nelly Longstaff, who grew up in the bath industry, wrote "Then for his bath! The attendant would draw the bath, tempering the water to the desired temperature. People were advised not to have the bath water too hot as this could be very debilitating. They were assisted into the water where they stayed for about twenty minutes. The attendant would give them a massage while they were in the water.

Although many patients did recover their health quickly in Mount Clemens, others found relief harder to achieve. Some who came were actually turned away. Those with cancer, pernicious anemia, acute infectious diseases, fevers, tuberculosis, and Bright's disease were advised to look elsewhere for treatment. On the other hand, many perfectly healthy men and women came to the baths in the hope of warding off chronic or disabling disorders.

56

The tubs were very large and deep and were porcelain lined. They had a headrest for the bather. The water was very corrosive, and the outside of the tubs looked pretty grim. The stalls around the tubs were marble, and the floors made of tile. The marble seemed to resist the effect of the water. The water was almost black and was quite buoyant. After the bath, the patient was assisted out of the tub and wrapped in a flannel sheet."

Mount Clemens listed 21 doctors in the 1897 *Headlight*, two of whom were women. Dr. Alice J. Hayward, M.D., and Dr. E. Amy Decker were specialists. They treated diseases peculiar to women and children. Female diseases, known as nervous prostration and sick headaches, were common complaints, but more serious ailments were also taken care of by the women doctors.

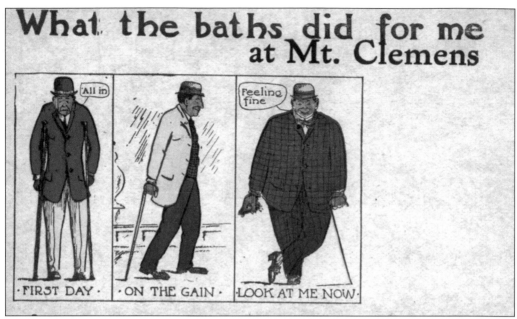

Mr. Darby Richardson was one of the many who left their testimonials behind following their miracle cure. He was suddenly stricken with rheumatism. After a three-month hospital stay, he was told by the doctors that they could do no more. He came to Mount Clemens, took 28 baths, rested for three weeks, took another 21 baths, returned to his former weight, and went back to his regular business duties.

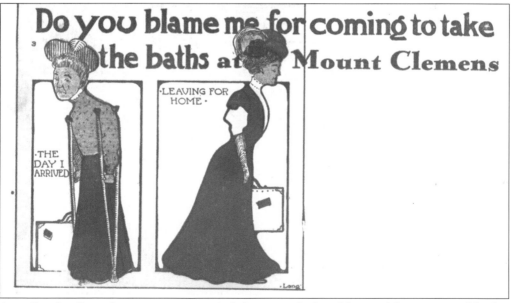

Actually the list of symptoms cured did not include old age. The series of baths, massage, and rest could, however, relieve chronic pain which can make the patient feel and look much older. Perhaps that is why so many people returned year after year, not only to ease their pain but also to restore the "bloom of youth."

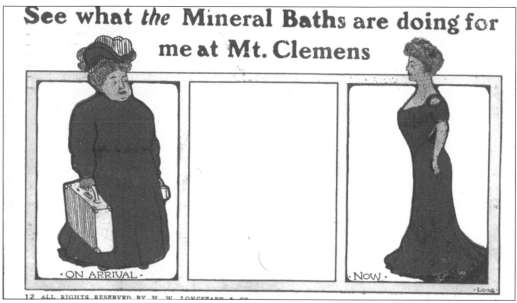

Obesity was one of the ailments listed in many bath house ads. Could they really soak those pounds away? A possible answer can be found in the ad for the Mount Clemens Mineral Springs and Bath House from 1883. The ad describes how, by placing the body containing low density fluids into heavier liquid, the cure forced the accumulated fluids out. Thus the loss of water weight?

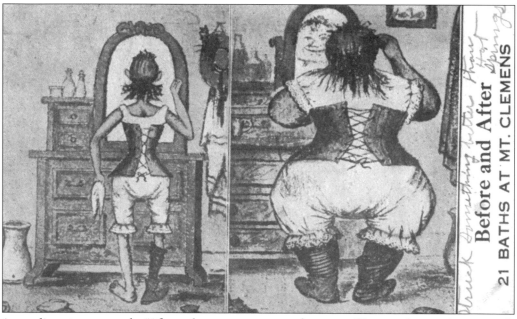

According to one ad, "After almost any sort of severe illness, the patient needs 'conditioning' or 'seasoning' before taking up the routine of home, business, or professional life. The psychological benefits of a complete change of environment supplemented by such mineral bath therapy as is to be had at Mount Clemens. . . is most advised for convalescing patients."

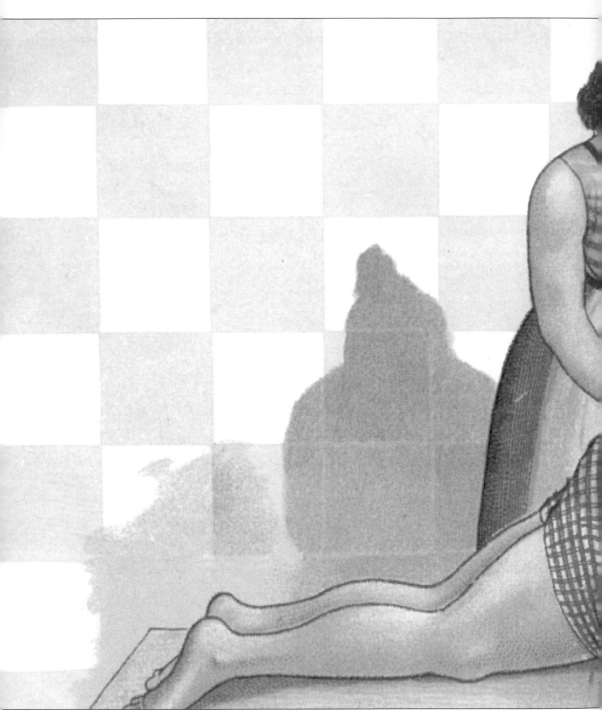

This was not a common scene in Mount Clemens. Generally speaking, men were massaged by men, and women were given female attendants. This rubber, however, might have been the attendant for 10-year-old Bessie. *The Past Is The Future* tells her story. "She was 'laid up in bed unable to move.' If her mother even straightened the sheets, she would cry in pain. Bessie remembers coming to Mount Clemens once a

John's enjoyment.

Mt. Clemens, Mich.

week for 21 weeks. . . Bessie was placed on a stretcher and lowered into the mineral bath. She remembers a very large woman rubbing her with salt and other things and massaging her body. Finally 'they put me in a cold shower.' The pain gradually subsided, and Bessie gained back her strength and resumed a normal life."

A key to the success of the baths was the "rubber." Once heat and water opened the pores, it was his job to see that toxins escaped. Louis Sonnenberg loved to tell his story. "I have rubbed, pinched, slapped, massaged, and manipulated the muscles of small men, big men, lean men and fat men, too. I have bathed men from Pittsburgh steel mills, baseball players, prize fighters, the sporting fraternity, preachers, politicians,

John's suffering!

Mt. Clemens, Mich.

millionaires, poor men, alcoholics, stretcher patients, and those afflicted with ailments from almost every disease known to man. Every case seems to be different. Some yield quickly to treatment and other cases do not show beneficial results for two or three weeks, in some cases not until the patient has been home more than a month."

Where I Left My Aches and Pains at Mount Clemens

Many bathers came on crutches and left them on the wall as a symbolic gesture representing their "cure." Others were carried in, unable to bear the pain of sitting up much less walking. Former bath house attendants can still be heard today telling their stories of bathers who went from crutches, to cane, to walking happily out the bath house door.

Great Treatments at Mt. Clemens

Hope my little Boy is being good While I am away.

Daddy

The baths were indeed "great," but they were also very potent. Robert Taylor, a famous comedian of the day, made the mistake of underestimating the water's power. He stuck his head under the cold mineral water tap after his bath. The gas is much stronger in the cold water, and Taylor was overcome. He was lucky to survive the experience. Bathers were regularly warned not to experiment with the water.

The list of afflictions treated at the Bath City is long and impressive. A few of the ailments that brought people to the bath houses were rheumatic afflictions of all types, stiff joints, sciatica, lumbago, gout, diabetes, kidney and bladder problems, dyspepsia, constipation, St. Vitus Dance, and general debility. Skin diseases, such as eczema, psoriasis, acne vulgaris, and salt rheum were also treated.

In this day of modern medicine, it is hard to believe that taking a bath could have cured so many. No, everyone wasn't cured. According to the *Pageant of Progress*, "It is proved by accurately kept statistics that 90 percent of the visitors are greatly benefited and at least 50 percent permanently cured."

Although bars were abundant in Mount Clemens, the internal cure was not alcoholic in nature. The artesian well water was known to speed the bathers on their way to good health. Numerous mineral springs were available where visitors could sit and sip the water while making new friends or getting re-acquainted with old ones.

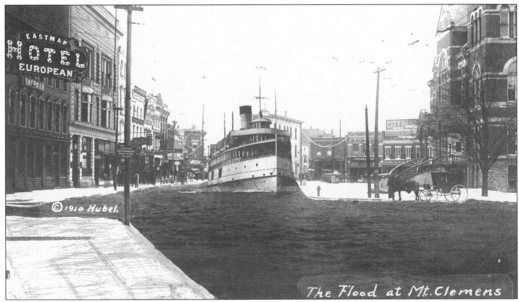

This is not technically Bath City humor, but it was one of the most popular postcards of the day. Since the city tended to flood regularly with the coming of the spring rains, evacuations by boat were a common sight. Generally speaking, however, the rescue vehicles were more in the rowboat category. Thanks to the spillway, built in the early '50s, Main Street no longer floods.

Three
INDEPENDENT HOTELS

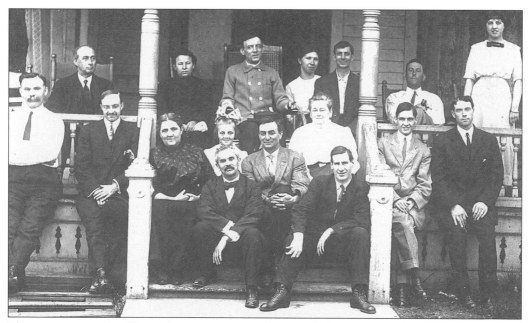

These guests at the Chase Cottage pose on the porch for a postcard picture. The Chase Cottage was a private home, but when sleeping space became tight in the bath era, many houses were turned into small hotels. It was first established by Eugene P. Chase. It was located at 22 South Walnut and opened in 1896. Mrs. Chase was known for keeping a "home-like and attractive residence."

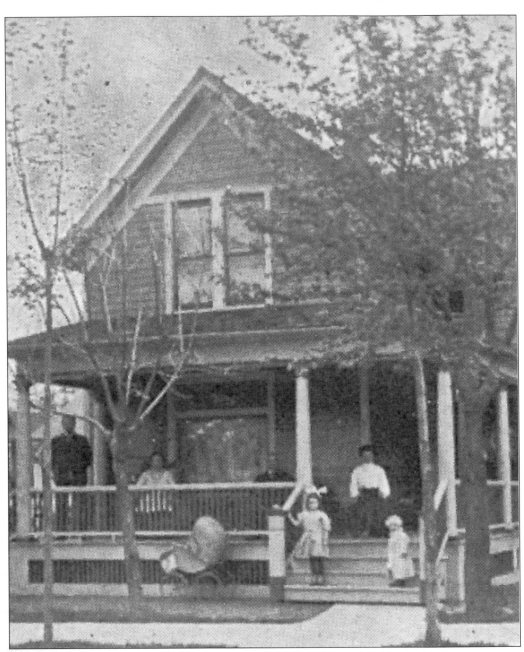

Since many people opened their homes to boarders, it was hard to find information on all of the hotels, boarding houses, and cottages pictured in this book. The name Allegheny Cottage would seem to indicate that the owner came from Pennsylvania, as did John R. Murphy, who called his summer home Allegheny Villa. There was no available information that this cottage had any connection to the Murphy family. Perhaps the first people who came to stay at the newly opened, and yet unnamed, boarding house came from Allegheny. These are all conjectures, of course, so it is up to the reader to make his own decision. The cottage was located at 146 North Front Street.

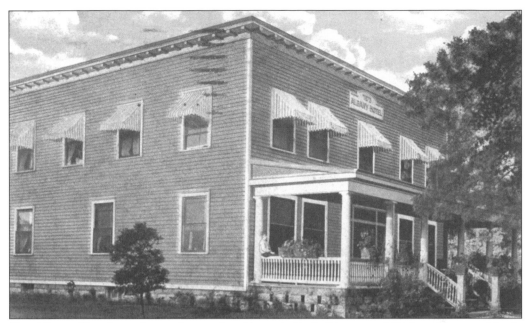

The Albany Hotel was located near the Olympia Bath House at 112 Cass Avenue. Meals were strictly kosher and supervised by Mrs. Benjamin Muscovitch. Mr. Muscovitch was in charge of seeing to the other needs of their guests. The hotel had 40 rooms at reasonable rates.

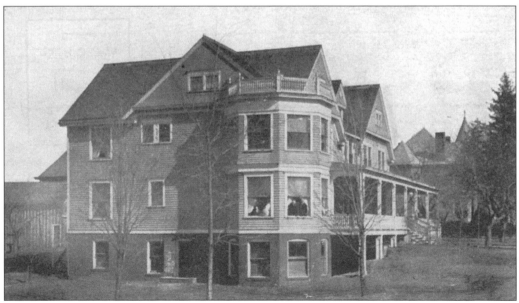

W.C. Cameron was the owner of the Cameron Cottage, located at 228 South Gratiot. His home was large enough to accommodate 60 summer guests. In the peak years of the bath era, the bath houses stayed open all year, but the summer was still the time when most people could afford to be away from home for three weeks.

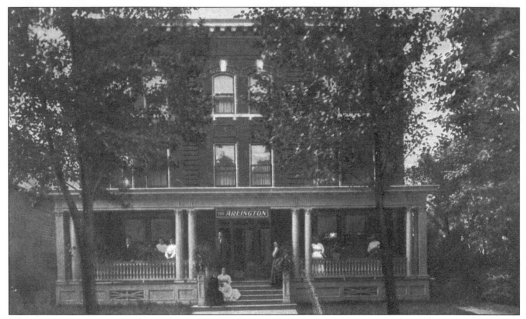

The Arlington was a boarding house located at 125 Cass. Boarding houses became prevalent on Cass during the bath era. The large homes were easily converted or added on to in order to accommodate guests. According to a 1985 newspaper article, the Arlington was originally built as a Salvation Army barracks with a large dining room and dispensary.

The Hotel Lawrence, previously known as the Arlington, was well situated for a bath era boarding house. It was, however, one of those tragic stories of a building that outlived its usefulness. Once the bathing craze was passed, the Lawrence became an unofficial home for indigents. It was vacated in 1985, and in 1987, fire destroyed the old hotel. The tragedy was that two people died in the deliberately set fire.

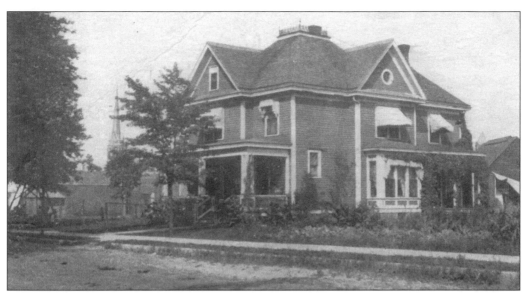

The Bishop was built around 1910 by Edwin A. Bishop, who served as its first proprietor. It was originally built as a private residence. It was located at 20 North Avenue. In 1954, it was converted to apartments. Although it was not in the heart of the city, the church steeple in the background shows that it was still convenient to downtown.

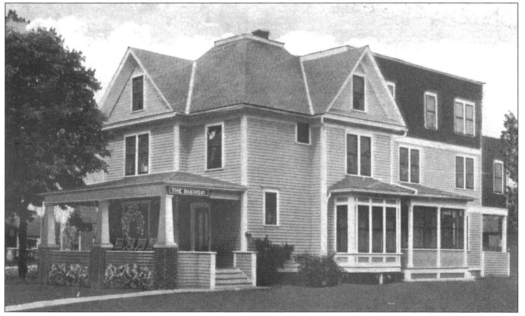

Comparison of this postcard with the one above shows how many small residences were converted to accommodate more visitors by means of an addition. The Bishop obviously was doing well enough that the owners felt extra bedrooms were needed. They were very careful to preserve the porch, of course, since porches were well used during the bath era.

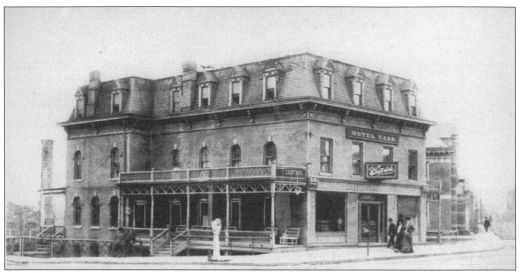

The Hotel Cass was located at the corner of Broadway and the old Market Street Bridge. The address was 10 Front Street. The phone number was 290. In later years, it would be known as the Broadway Market, where locals went for meat and other essentials. The Hauptmans ran the market.

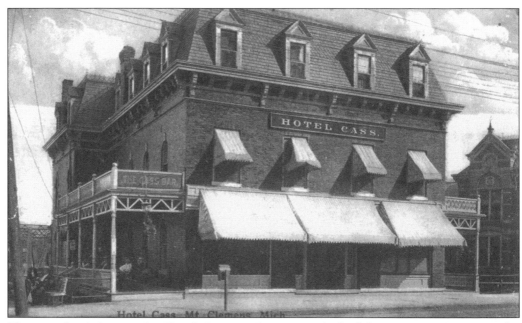

The people sitting on the Hotel Cass porch were typical of the summer visitors to the bath houses. They took their bath and sat rocking on the porches. While this may seem lazy in today's fast-paced world, it was really part of the cure. Many physicians believed that patients improved faster in the winter because they stayed in and rested rather than taking advantage of the city's amusements.

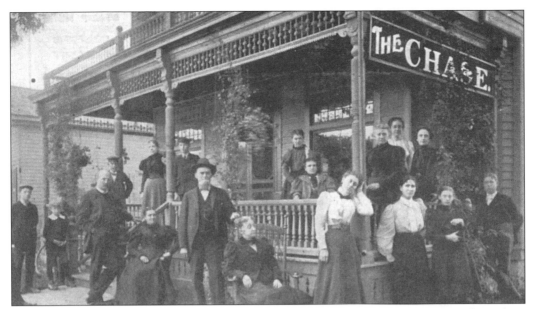

Cutter wrote, "Guests at the Chase Cottage enjoy the freedom of the private boarding house, the quietude of a home and many of the advantages of the larger hotels." With 22 sleeping apartments, it could not be considered large, but it was well located. Close to the Clementine, Olympia, and Medea, it offered guests convenience and choice.

The Edison Hotel, at 25 Crocker Boulevard, was named after the great inventor who saved the Mount Clemens stationmaster's son. The hotel was opened in 1908 by William Diehl. It was later taken over by Mrs. Szeinbach, who specialized in kosher cooking. The name was changed to the Crocker Hotel in about 1953. It was demolished in 1960 to make room for the municipal building.

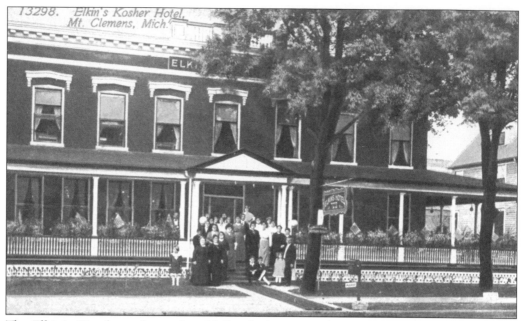

The Elkin's Hotel was located at 33 South Gratiot and was strictly kosher. When Sam Elkin died, the Ullrich Bank took over the hotel. Leon Mandell purchased it and renamed it the New Glenwood. This was apparently confusing, as three years later, he changed the name again to the Mandell Hotel.

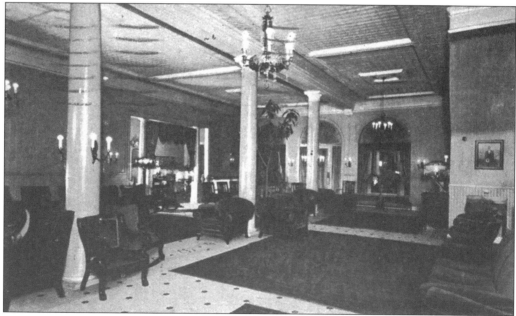

It's hard to believe from the elegant lobby, but the Elkin's Hotel was the scene of boxing matches with purses ranging from $5 to $25. Grudge fights were often staged. The contenders put up $25 each, and the winner took all. This was, of course, a bonus for the promoter who didn't have to cover the cost of the purse from his profits.

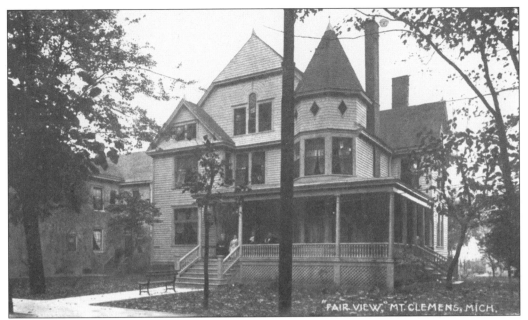

The Fairview, also known as the Fair View, was located at 43 South Gratiot. Mrs. J.E. Brehler managed the 75-room hotel. It was typical of the elegant homes with interesting roof designs and large porches that were turned into boarding places during the bath era. Many of these period homes remain today, adding a touch of class to the neighborhood.

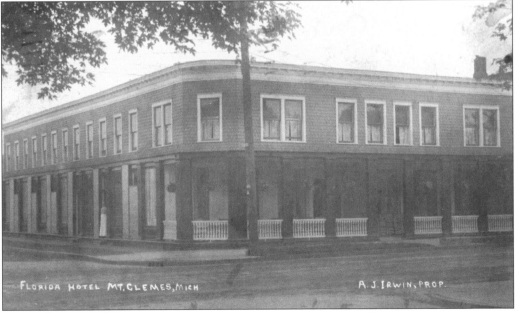

The Florida Hotel was situated at 58 East Street. Built more like today's motel than a bath era hotel, the Florida still had room on its porch for a rocking chair or two. For those unfamiliar with East Street, it was approximately the equivalent of today's North River Road.

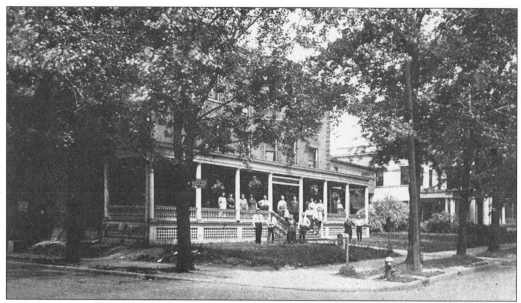

The Glenwood received one of Cutter's highest compliments. "Visitors desiring quietude as well as convenience, and nice associates as well as good company, find them here." Harry Roy, the proprietor, saw to the needs of his guests and provided a well-equipped, light and airy temporary residence. All rooms were considered outside accommodations. It was located at 100 Cass Avenue.

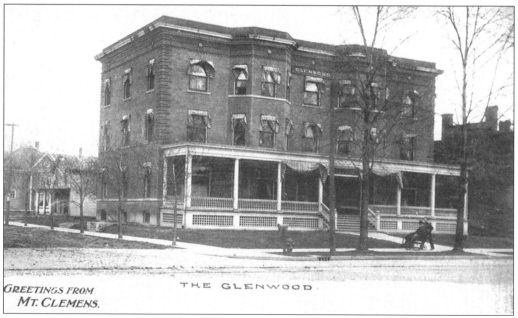

GREETINGS FROM
MT. CLEMENS.

THE GLENWOOD.

At one time the Glenwood was known as "by far the largest and best equipped private boarding house in the city." Cutter was clearly impressed. There were 40 rooms. Some of them were suites to accommodate those who brought families or just needed room to stretch. It was located next to the Olympia Bath House, but was also close to the Clementine and Medea.

A common sight in the city was hotel guests in rocking chairs enjoying a restful afternoon on the porch. These Glenwood guests, no doubt, gathered on the lawn for a special occasion—the postcard photographer's arrival. Since these postcards were sent all over the country to friends and loved ones, they were an excellent advertisement.

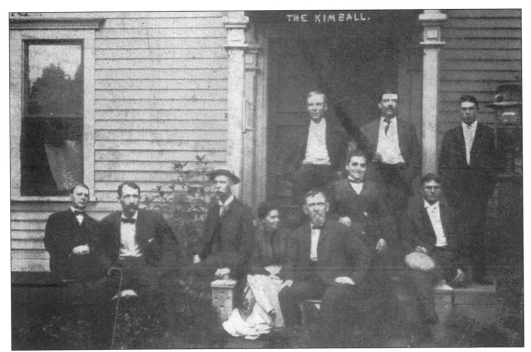

Conveniently located close to three of the major bath houses, the Olympia, Clementine, and Medea, the Kimball Cottage boasted a home-like atmosphere. According to Cutter, "Parties desiring a private boarding house at reasonable rates will be pleased at the Kimball." The hotel was located at 58 South Walnut.

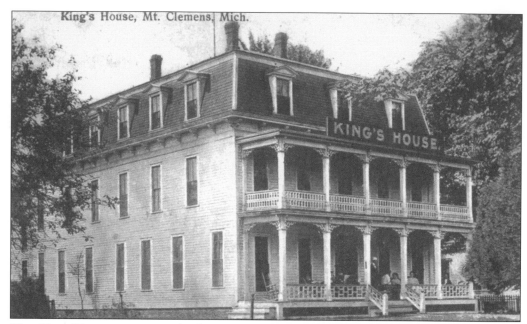

The King House was proud of its reputation as a family hotel. Cutter assured his readers that they would meet nice people and be treated well by the proprietor. It was located at 157 Cass Avenue about midway between the railroad tracks and the business district. The proprietor was C.L. King.

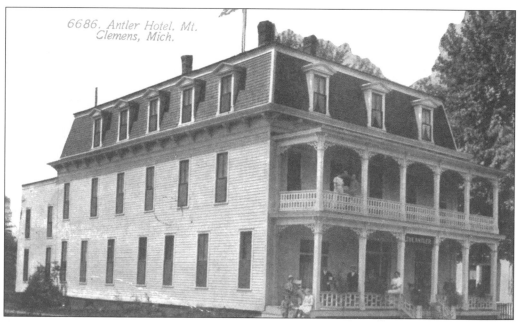

King's House was also known as the Antler Hotel. The change of name and proprietor did not change the excellent service and friendly atmosphere. The house was surrounded by a spacious lawn and large trees, a true home away from home for weary travelers. It accommodated 100 guests.

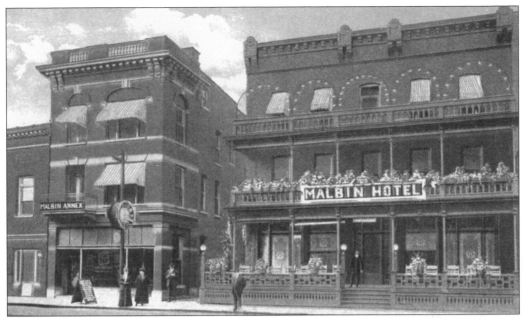

Jacob H. Malbin left Russia at the age of 12 and, after traveling extensively, decided to try his luck in America. He was successful, but was having trouble dealing with his rheumatism. He was told to see if the Mount Clemens baths could help. Like so many before him, he chose to stay, and he bought this hotel at 12 South Gratiot. In 1923, he founded the furniture store familiar to longtime city residents.

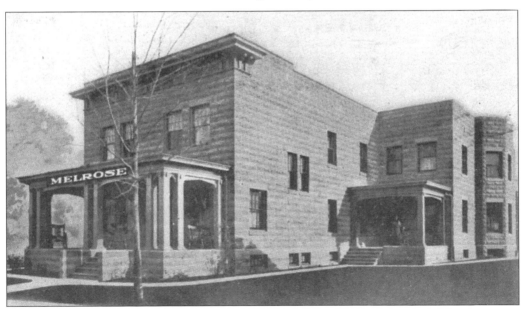

The Melrose Hotel was built in the early 1900s and was located at 25 South Avenue. It was only a short distance from Cass Avenue, and the Olympia and Clementine bath houses. Cutter was impressed with the cement block exterior. He thought the hotel "closely resembles a dressed stone building, making a handsome appearance." Mrs. Adam Blayney was the proprietor.

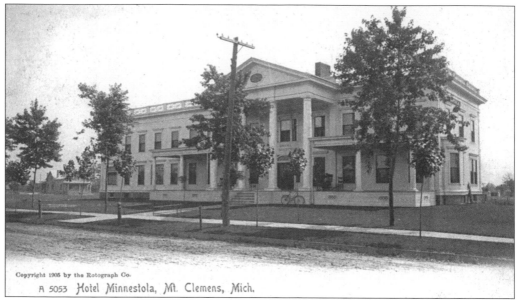

Copyright 1905 by the Rotograph Co.

A 5053 Hotel Minnestola, Mt. Clemens, Mich.

The Hotel Minnestola, located on North Avenue diagonally opposite Saint Joseph Sanitarium and Bath House, was described as "a little gem of a house." Unfortunately, after eight years of tremendous success, it fell victim to spontaneous combustion. The hotel might have been saved if the residents had been able to wake the central telephone offices. Fortunately all 17 guests escaped, although one man was injured and another lost his savings.

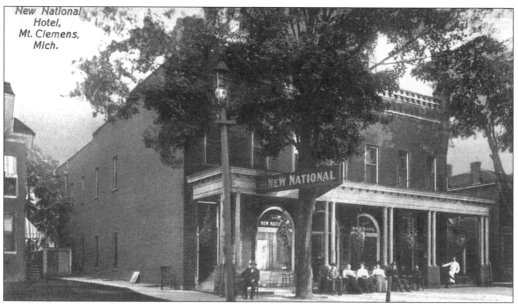

New National
Hotel,
Mt. Clemens,
Mich.

Opened to the public in 1900, the New National could accommodate 45 guests. The proprietor was Mr. M. Shaaf, who had previously run the National Hotel, which was across from the city hall. The new hotel at 33 South Gratiot was less than a block away from the first and the heart of the city. It was also conveniently located one door from the Medea Bath House.

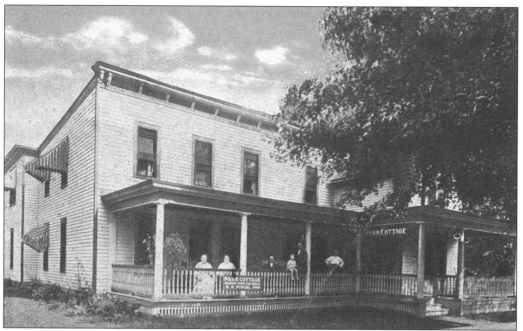

The Park Cottage was located at 133 North Front Street and run by J.C. Pingle. There were 30 rooms for guests, and the rate was $5 to $6 for a week's stay. As one of the smaller accommodations, it also had a smaller price. A list of hotel prices for the early 1900s shows everything from $5 to $28 for weekly rates. The Park listed only daily rates of $3 to $6.

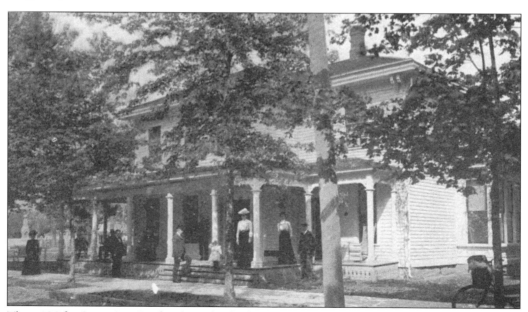

The 1906 *Cutter's Guide* described the Park View House as "newly furnished, everything nice and clean. . . " The house was located at 148 North Gratiot, opposite Clemens Park. The Fountain Bath House was only one block away. Mr. H.J.F. Baumbach was the proprietor who catered to his guests' every need.

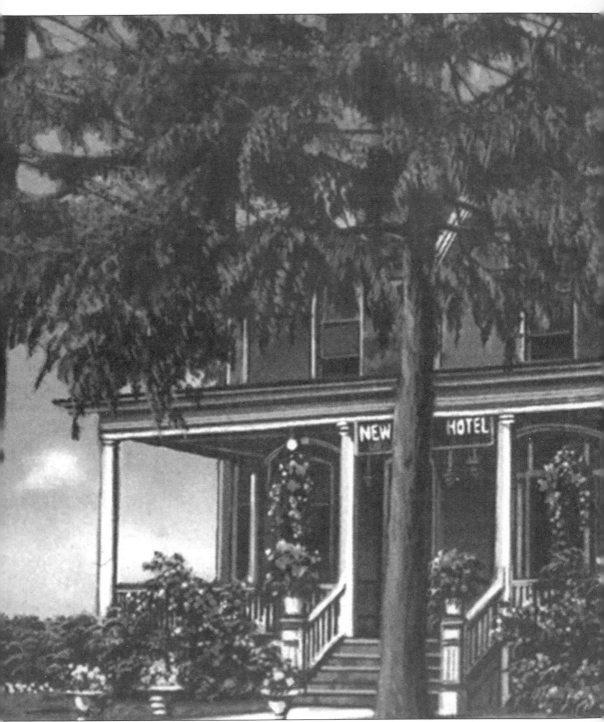

The address for this popular hotel, the New York, was 146 Cass Avenue. Located in one of the city's finest neighborhoods, it was surrounded by shade trees and brightly colored gardens. It had 50 guest rooms and was strictly kosher, providing Hungarian-style meals. Sam Ginsberg was the first proprietor, and Mr. and Mrs. David Willinger

took over later. Cass Avenue was the road into town from the depot. The large, ornate homes, many of them still boarding houses, that line the street today keep the memory of the bath era alive. The elegance of the major hotels is reflected in these remnants of a bygone day.

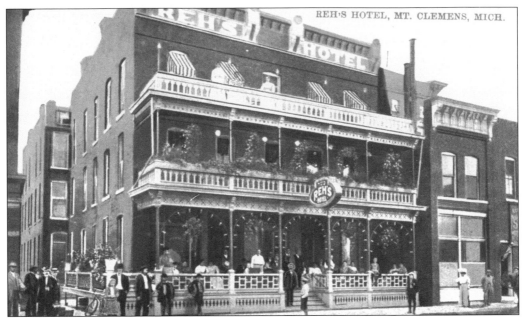

Reh's Hotel was formerly known as Hall House and held an excellent reputation for reliability. When Mr. R.H. Reh leased the building, he had over 20 years of experience in New York City and was well prepared to continue the fine service of the hotel. Reh's was located directly across from the Medea at 112 South Gratiot.

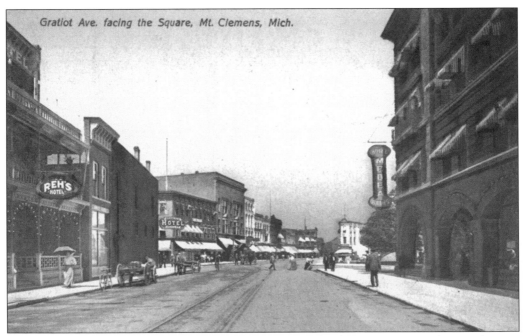

Gratiot Ave. facing the Square, Mt. Clemens, Mich.

Reh's Hotel was a strictly Jewish establishment. All foods were prepared according to the ancient customs and religious beliefs. Mr. Reh was known as a "very agreeable and gentlemanly host," and his hotel was usually overflowing with visitors from all parts of the country, especially New York. Reh's had a good ratio of return guests.

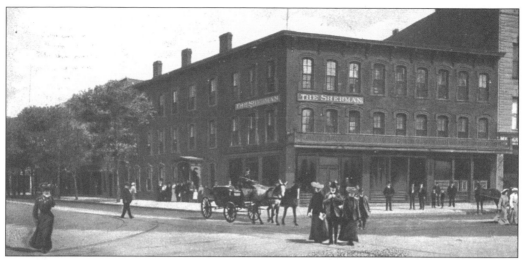

The Sherman House, located at Cass and what is today Main Street, was built in 1866 by Henry Connor. It was added onto in the 1880s. According to one newspaper article, "Soldiers of the Civil and Spanish-American wars were dined, wined, and mustered out at the hotel, and banquets tendered to the dignitaries of the church and state were frequent."

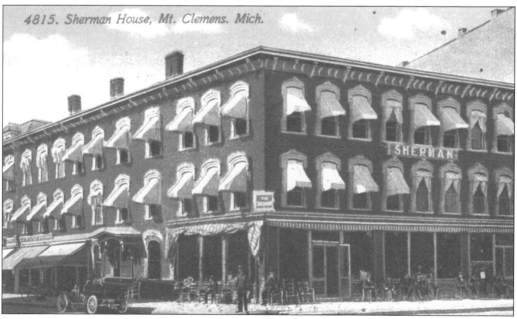

Local columnist, Rodney Waterbury describes the Sherman Hotel like this: "In the palmy days of Mount Clemens' popularity as a health resort, the Sherman House teemed with gay festivities, day and night. Here theatrical stars, politicians, and other celebrities, wined and dined, and held revel appropriate to the days of five-cent beer, ten-cent Scotch and twenty-five cent concoctions."

The Sherman House was located in the heart of the city. With its location in the business district, it was popular with traveling men as well as bathers. Directly across from Court House Square, it was convenient for those in town on legal matters. J.R. Tremble was the manager. When the demand for hotel rooms diminished, the Mount Clemens Savings Bank took over the space. Today the building is home for the Huntington Bank.

Cutter described this scene well, "The Sherman has a large office, facing both streets, and it is a favorite resort of the male guests of the different hotels, who find it the most popular of the public places for socially meeting their gentlemen acquaintances and in witnessing the passing of the daily parade of promenaders who stroll by this prominent corner from early morn until the late hours of night of the busy season."

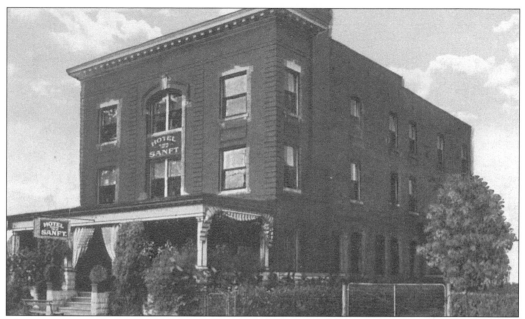

The Sanft Hotel was located at 30 South Walnut. While that was close to the bath houses, it was also close to the smell of the heated water. This postcard writer didn't seem to mind much. "The sulfur smells are unpleasant but they say that over one hundred thousand people have taken the baths this summer. I hear of marvelous cures. Am certainly better myself."

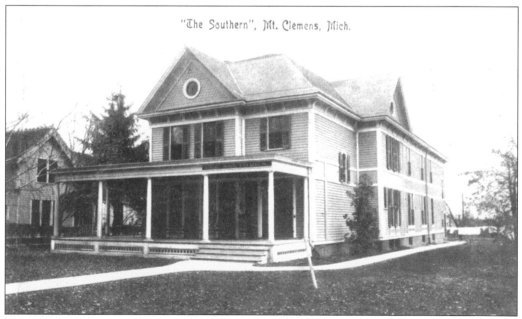

Could a person from up north stay at the Southern? Probably, but this postcard author was likely from the South. He seems to have expected more from "Mount" Clemens. He wrote, "This is an attractive country, but too level for my tastes. No hills anywhere." The Southern was located at 97 South Gratiot.

Macomb St., One of the busy sections
at Mt. Clemens, Mich.

The Stag Hotel was located in the heart of the city at 47 North Walnut. For those guests who liked to be in the middle of the action, the Stag was the place to be. It was obviously the ideal stopover for the traveling man, as well as bath house visitors

The Tennessee could be found at 34 South Walnut. It was only one block from Cass, so was convenient to the Clementine, Medea, and Olympia. In 1905, a brick addition, seen in this postcard, was added. Mrs. R.T. Faris was the proprietor. Room and board was $7 to $9 a week.

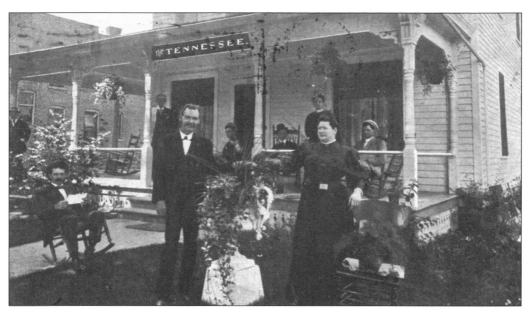

Were the proprietors just posing here or was there some kind of ceremony going on? If they were posing, who is the guest in the rocker who needed a front row seat? If it was a ceremony, where were all the guests who filled the porches in the other postcards? Sometimes postcards create a lot of questions for the generations that follow.

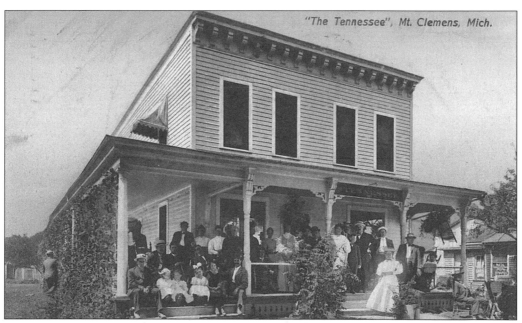

The Tennessee is another example of a hotel with a very large porch. Their columns added to the look of the building, but, more importantly, the porches provided plenty of room for rockers. Comparing this postcard with the one on the previous page, it looks like the Tennessee guests also wanted shade. The ivy was a decorative touch, but it also gave some semblance of privacy.

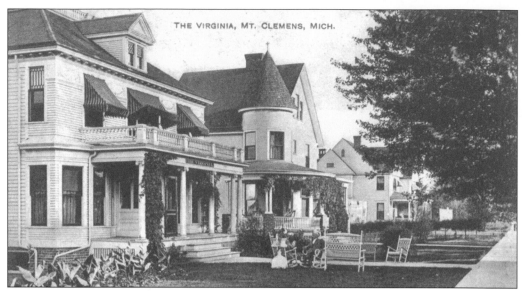

The baths attracted groups of people from different areas of the country. When someone was "cured" and returned home, the news spread quickly. The next year others joined the pilgrimage to Mount Clemens. The smaller hotels took names meant to identify what part of the country their guests generally came from. Thus, for example, the city had a Tennessee, a New York, a Florida, and, of course, it had a Virginia. The hotel was located at 231 South Gratiot.

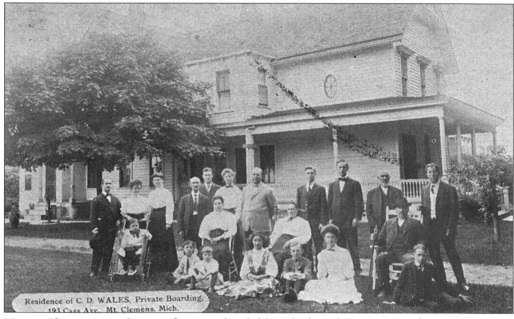

Mount Clemens was known for its splendid hotels, but the cost was often out of reach for the average bather. *Headlight* put it well: "The visitor to Mount Clemens need not, unless he so desires, indulge in the luxuries offered at the hotels, neither need he feel obligated to remain away from the baths because of expected expense." Private homes, like C.D. Wales' Boarding House, were readily available.

Four
THE MINERAL SPRINGS

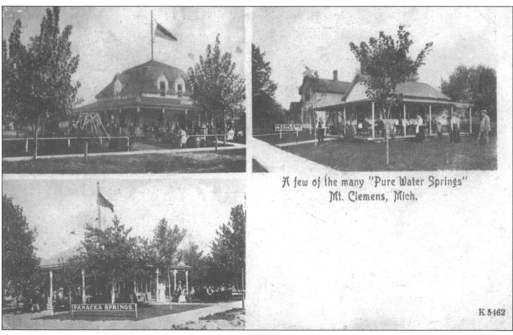

A few of the many "Pure Water Springs"
Mt. Clemens, Mich.

PANACEA SPRINGS.

K 5462

Bathing in Mount Clemens mineral water was considered essential for restoration of good health, but sipping the Artesian well water was also recommended by concerned physicians. Numerous springs, primarily located on the south side of the Clinton River, provided a place for bathers to wile away the hours, listening to music, playing cards, or just relaxing. The message on this card reads, "This is where we get pure water."

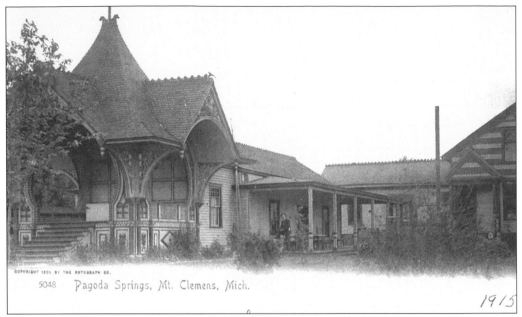

5048 Pagoda Springs, Mt. Clemens, Mich.

1915

The oriental pagoda attracted visitors to Pagoda Springs, which was built in 1891. When E.R. Egnew heard that a visitor had claimed to have been cured by the spring water, he started what would turn out to be big business in Mount Clemens. He had the water analyzed and found it truly was medicinal. It was bottled as "Little Pody" and used by the Michigan Railroad in their dining cars.

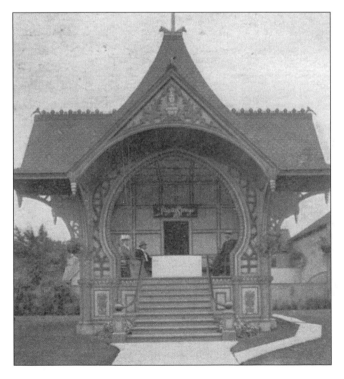

The choice of location for the Pagoda was made by Egnew's pet eagle. When he escaped from his home in the Avery House, he was so excited that he flew around wildly until he could fly no more. Being a superstitious man, Egnew marked the spot where the eagle fell from the sky for his spring, at the corner of Dickinson and Second Streets.

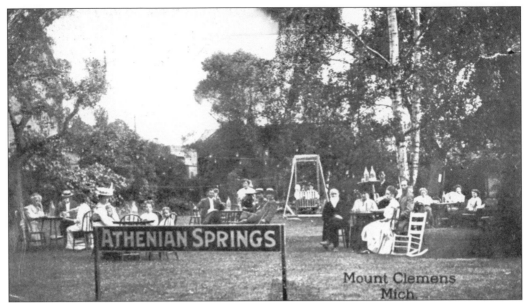

The Athenian Springs, located at 199 Cass Avenue, was in business from 1900 until about 1916. Dr. Abner Hayward, the first physician to accept the therapeutic power of the water, was the operator. Apparently, one postcard writer didn't agree with Hayward's assessment. He wrote, "Nothing to drink but mineral water and no one could drink more than a teaspoonful."

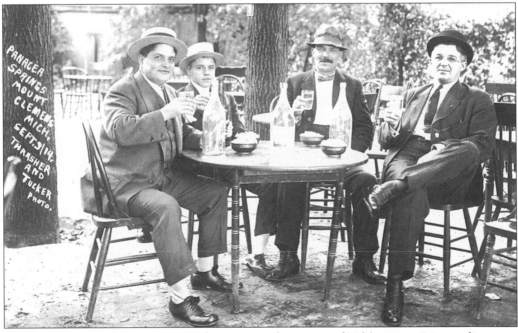

These gentlemen look content to be sipping the "King of Table Water." According to a Panacea Springs ad, "The benefits are undeniable." The "slightly alkaline water" had a laxative effect that was prescribed for chronic illness and liver or kidney problems. One writer complained that she hadn't been able to get "drunk on these waters."

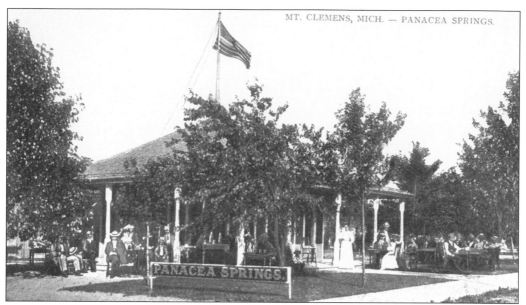

Panacea Springs opened in 1903, with Frank W. Preussel in charge. It was located at the corner of Crocker and Second Streets. The pavilion was octagonal in shape and accommodated 500 people. An orchestra balcony and maple dance floor provided an evening of fun for those who weren't in too much pain to participate.

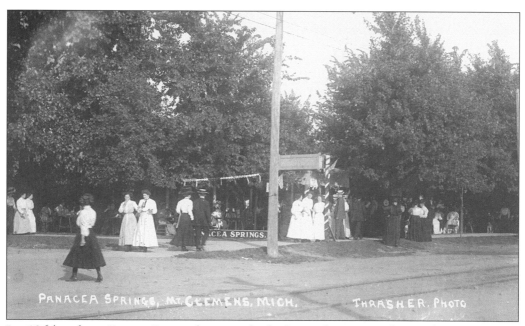

In 1964, when Byron Preussel was asked about the water, he said, "It was not uncommon to drink two half-gallons of the spring water at one sitting. The all-time champion downed 14 half-gallons." The visitor who sent this card must have been there. She wrote, "This is the place where they drink mineral water until your back teeth float."

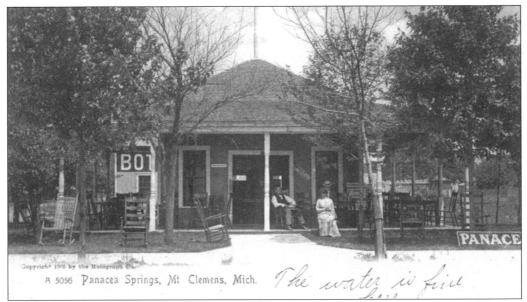

Copyright 1905 by the Rotograph Co.
A 5056 Panacea Springs, Mt Clemens, Mich. *The water is fine here*

Unlike the author of this card, another springs visitor wrote, "My dear mother, Just tasted the delightful water you will drink while taking your baths here and indeed you have my sympathy. Having a good time. Will see you later." Perhaps her mother found the water more to her liking. After all, it was advertised as the "Water that made Mount Clemens famous."

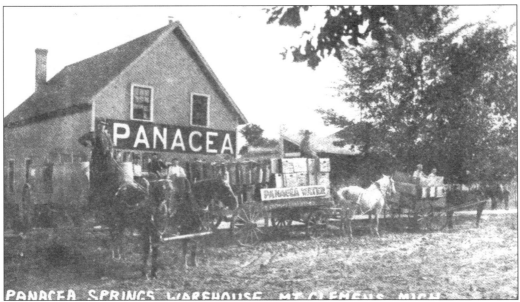

The Panacea and other water bottlers shipped their product across the country for use as a table water or a tonic. The state capital building staff drank Mount Clemens water, as did many who worked in downtown Detroit establishments. One visitor had heard about the popularity of the water but wasn't all that impressed. He wrote, "The water from the springs is shipped all over the United States. Not much taste to it but clear as crystal."

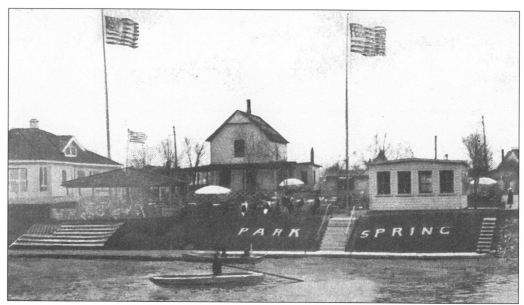

Garvey's Park Spring was located a short river crossing from the Park Hotel and Bath House. Bathers could spend warm summer days sipping Artesian well water, eating popcorn, playing cards, or just listening to the old Victrola. In the winter, the river came alive, especially during the yearly carnival. The locals entertained with fancy figure skating, speed skating, and barrel jumping.

Garvey Park Springs was a favorite spot for locals as well as visitors from 1914 until 1936. Elijah Garvey was proprietor of the business that was located at 18 Riverview. Just across the river from the Park, it catered to Park guests. In 1937, the springs were combined with the roller rink next door. The hardwood floor can still be seen in the stock room of Jock and Meldrum Plumbing Supply.

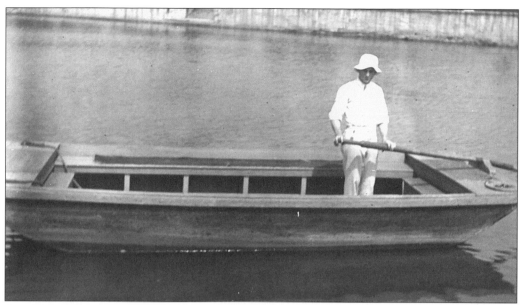

On this 1927 personal postcard, Bert Lozen uses one-man power to propel the Garvey Park Springs boat across the river to pick up guests from the Park Hotel. "They were like cattle," said Lozen. "We were only supposed to have six people on each side, but they tried to crowd in." Despite the complaint, Bert loved working at Garvey's for 50¢ a day.

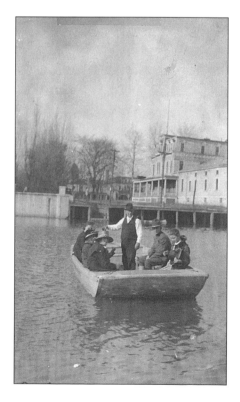

Apparently the crowds weren't so fierce in 1916. This Garvey employee crosses the river with a half-full boat. The message on the back says that the Riverside Hotel and the Plaza Hotel and Bath House can be seen behind him. The dock was located at the foot of Jones Street. The Park guests could ring a bell to call the boat to their side of the river.

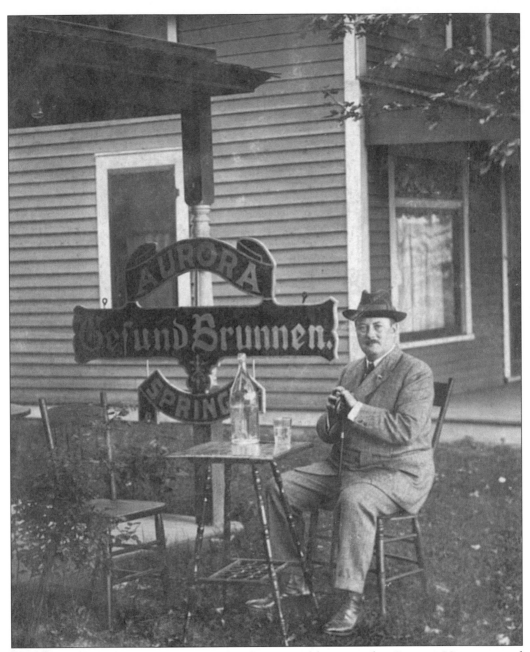

From the information in the history books, it would appear that Eugene Moser started the Sanitas Springs at 77 Crocker in 1898, sold it, and moved down the street to 35 Crocker. He opened Aurora Springs in 1905. In 1921, Lewis Peter took over the Aurora and remained proprietor until about 1930. The water produced by the springs was recommended by physicians to help the patient clean the body. According to the *Pageant of Progress*, "Water, these physicians know, is the universal solvent in the human body, the medium by which foods are rendered soluble by digestion and carried back into the blood current to be acted upon or eliminated through the kidneys or other organs."

Mrs. B.F. Jenne took over the running of Sanitas Springs from Moser. Like the other springs, Sanitas sold a lot of water. Perhaps that was because, as the Macomb County health officer at the time explained, ordinary water is heavy on the system and too filling. The well water was easier to drink, especially since most springs sold it for 5¢ a glass with unlimited refills.

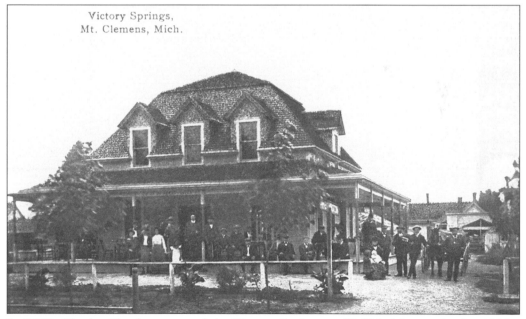

In 1892, Charles Shorkey opened the Victory Springs at 23 Third Street. In the 1930s, Nicholas and Mary Hanoitis took charge. In the early 1950s, the name was changed to Victory Garden. In 1909, W.A.B. sent this message: "This is a fine place to get a good drink of water. After a walk, one can drink three quarts, and it does not hurt a person like most water."

Springs

1—ARBOR
2—ATHENIAN
3—AURORA
4—IMPERIAL
5—MAPLE LEAF
6—PANACEA
7—ORCHARD
8—PARK SPRINGS
9—PEERLESS
10—SANITAS
11—VICTORY
12—PAGODA

Five
THE OUTSKIRTS

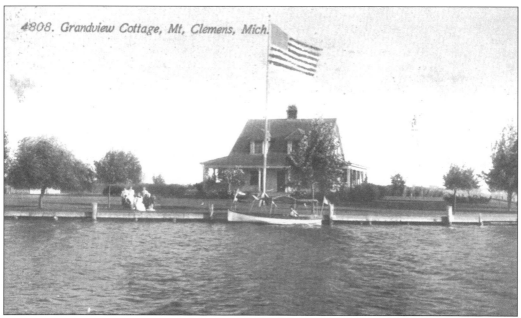

Like the many small houses that dotted the shore of the Clinton River, the Grandview Cottage had a grand view, indeed. The visitor could sit in the shade or sunshine and watch the river traffic. Excursion boats and fishermen passed regularly on their way to Lake Saint Clair and the excitement to be had in the Saint Clair Flats, known as the Venice of America.

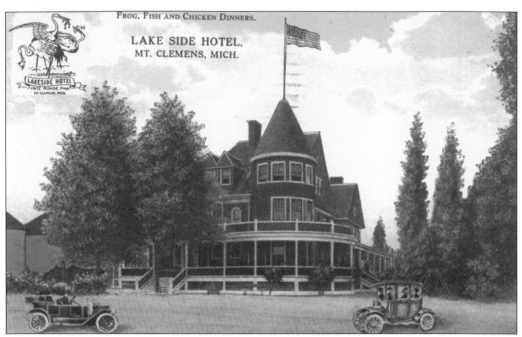

Located at the foot of Crocker, the Lakeside Hotel was famous for its frog, fish, and chicken dinners. It was a destination for bathers who wanted the cool lake breezes between baths. One visitor wanted more than just comfortable nights, however. He wrote, "Have lovely frog leg and fish dinners out here, but you can't get much of a meal for 10 cents here either."

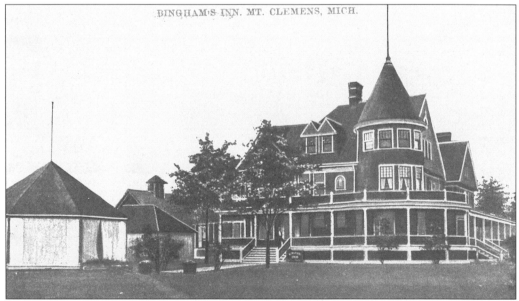

The Lakeside Hotel, built around 1895, was later known as McSweeney's and later still as Bingham's. Cutter extols the virtues of both "Mack" and "Bing" as gracious hosts, strangely enough in exactly the same words. In later editions, the name of the hotel, its proprietor, and his nickname were the only things that changed in the descriptions.

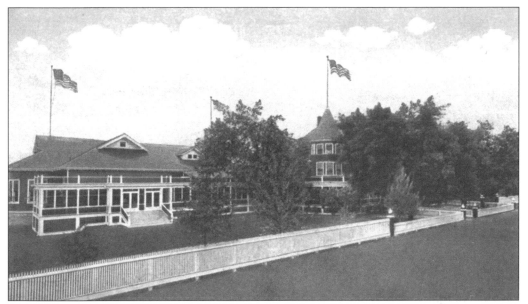

The Pontchartrain-on-the-Lake was another Lakeside hotel. Although the Pontchartrain was a favorite meeting place for locals as well as a destination for Bath City visitors, it was known for more than its cool lake breezes. Since gambling was a popular pastime for the men of the era, the "Ponch" was one of the many establishments that catered to the gaming crowd.

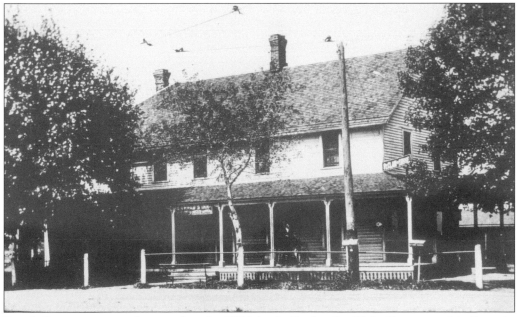

Frank Campau was a farmer, but in 1896 he built the St. Clair House on his farm in Lakeside. According to one historian, the hotel prospered because of "the capable management of the owner, who puts forth every effort in his power to promote the comfort of his guests." In later years when the hotel burned, what remained was moved across the street and is today the Sentimental Lady Saloon.

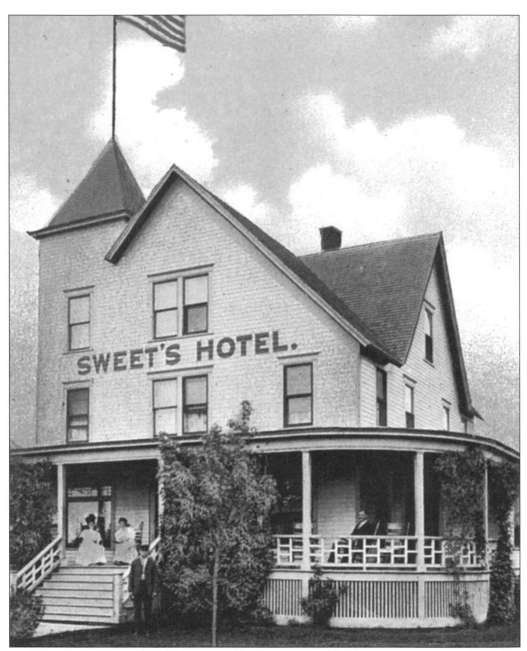

Early directories give the address for the Sweet's Hotel as "the mouth of the Clinton River." Actually, the hotel was at 32425 South River Road, but that address wouldn't come until later when civilization encroached on the swamps. It was not always easy to get to except by boat, but the bath house crowd, even the celebrities of the day, managed to find it. The hotel was originally owned by William Sweet, who died in 1906. His wife did her best to carry on but sold the hotel in the 1920s. It changed hands several times before 1959, when a group of boys, aged 7 to 12, were playing with matches and burned the abandoned hotel to the ground. The boys were lucky to have escaped from the upper story when flames engulfed the building.

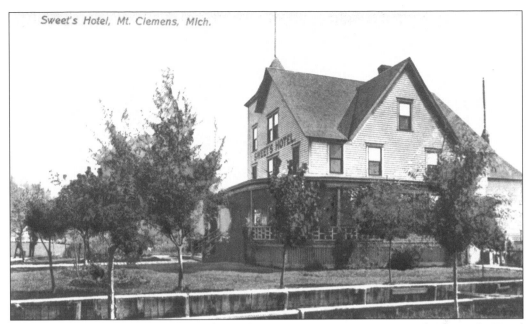

Sweet's Hotel, Mt. Clemens, Mich.

With an address like "the mouth of the Clinton River," it's easy to see why Sweet's Hotel was described as a hideaway. Roads being what they were in the early days, if the road was impassable for a car, Dutch Henry and his horse and buggy would deliver guests. For a short time in 1927, the hotel served as the first state police post in Macomb County.

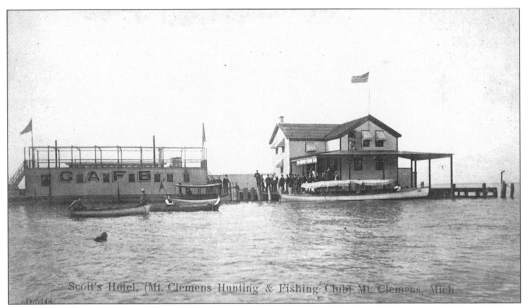

Scott's Hotel, (Mt. Clemens Hunting & Fishing Club) Mt. Clemens, Mich.

Scott's Hotel has an interesting history, having been first built as a lighthouse keeper's residence. When the light was decommissioned, the house was purchased by the Mount Clemens Hunting and Fishing Club. The light tower was removed from the center of the building which was constructed on pilings. This was as close to the lake as accommodations could get.

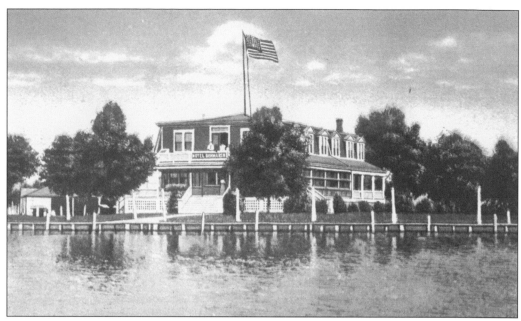

Opened in 1904, the Denmarsh Hotel was located on what is now North River Road near Conger Bay Drive. It was only 5 miles from the city and catered to hunters and fishermen as well as the bath house trade. According to Cutter, it was "thoroughly modern with stationary lavatories, electric lights, solid brass beds, box springs, hair mattresses, and a bath on each floor."

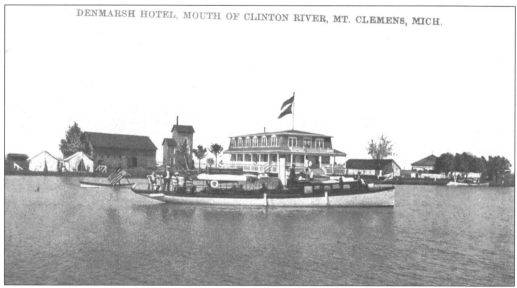

Food has always been a huge drawing card for hotels, but the Denmarsh seems to have specialized in fine cuisine. In addition to the public dining room, the Denmarsh had five private dining areas. According to Cutter, "The fish dinners are too well-known to need introduction here." A first-class bar was also run in connection with the hotel. The boat house provided all types of boats and launches.

Six
ASSOCIATED BUSINESSES

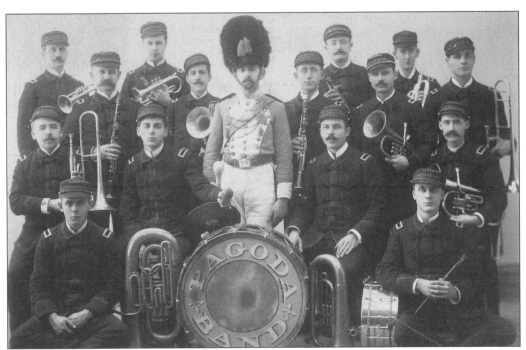

The Pagoda Band entertained in Court House Square, at local hotels, at the Pagoda Springs for which it was named, and at musical events throughout the state. Made up of local businessmen and professional musicians, the band was organized around 1891. Although local history books give the date as 1904, the *Headlight*, first published in 1897, includes a picture of the band organized 6 years before.

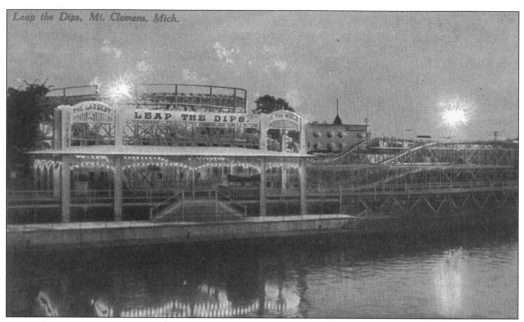

Leap the Dips, Mt. Clemens, Mich.

Leap the Dips, known as the largest roller coaster in the world, was located on the banks of the Clinton River, where the city's gazebo stands today. Most history books say that the coaster was built in 1913 by a Mr. Ingersoll. Thanks to a thoughtful postcard writer, however, it can be established that Leap the Dips was built much earlier. The roller coaster card was clearly postmarked 1905.

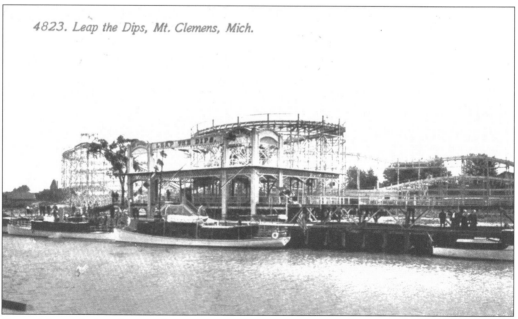

4823. Leap the Dips, Mt. Clemens, Mich.

One visitor obviously wasn't in too much pain to try out the city's star attraction. She wrote, "How you was? I am having a jolly time down here. You can have that horse and buggy if you want it. I don't. Well, Julia, I say that leap the dips as you call it is just fine. It would be apt to take your breath."

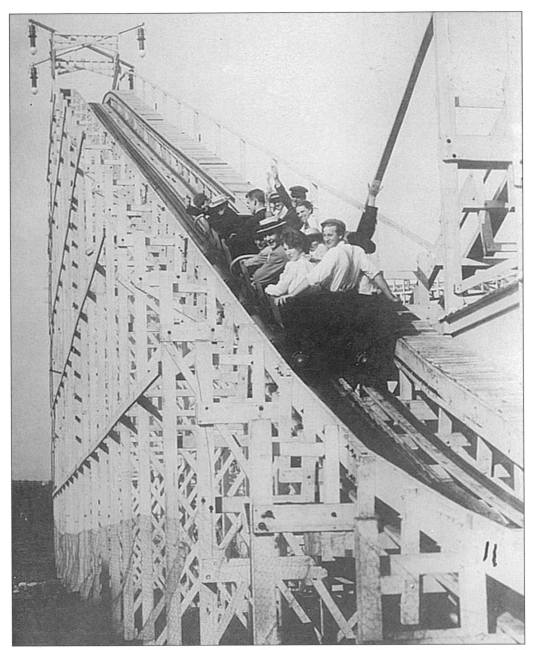

Mr. Ingersoll advertised his coaster as "perfectly safe, exhilarating and novel." No doubt it was for several decades. In 1923, however, while perhaps still exhilarating and novel, it was declared unsafe. Mr. Ingersoll had no problem getting rid of something so big. He called on the neighborhood youngsters who had brought him so many dimes for rides over the years. In no time the world's largest coaster was history. The kids were more than happy to tear down the old coaster and haul the wood away. For what purpose, one can only imagine—a club house with a "members only" sign, a tree house for hiding away from parents, or a bonfire for roasting hot dogs or mourning the end of summer?

In 1905, Robert Peltier used his $300 savings to purchase a Magic Lantern projector. He used a bed sheet as a screen and borrowed chairs from a local undertaker to make the first movie house in the city and the predecessor of the Bijou. It wasn't until 1908 that Bob took a partner and remodeled, renaming the larger theater Dad and Bob's Bijou. Throughout the years, Bob increased his theater in size and importance until it

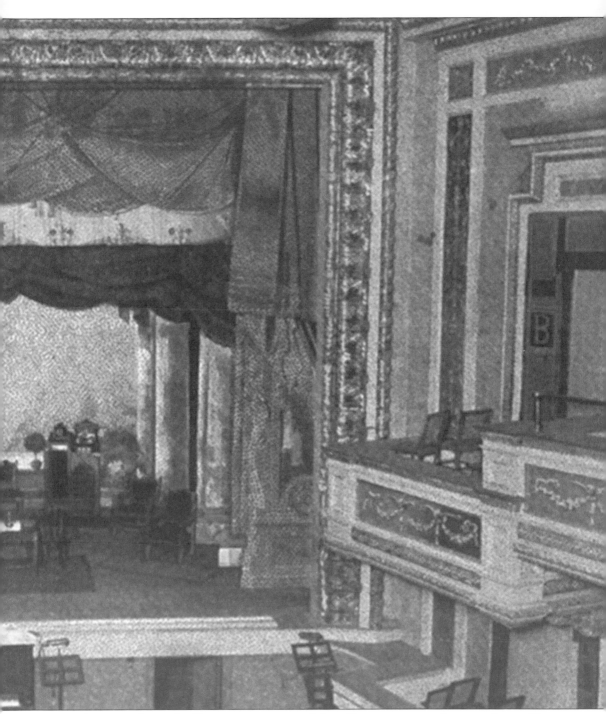

attracted topnotch vaudeville troupes, stars of the silent screen, and entertainers like the John Philip Sousa Concert Band. It was obviously popular as the message on this postcard indicates: "I believe I am going to get better. I feel a little better now. I go to the theatre on the opposite side every night and then come back and go to sleep."

"The Chateaux", Mt. Clemens, Mich.

For those who could afford accommodation at the post-Park Hotel, the Chateau at Park Avenue and East Broadway provided a little amusement. The back of this card says, "This is where the gambling goes on. I was taken all through the place and it is beautiful." Another postcard author might have spent time there. He wrote, "Will you have the extreme kindness to send me 50 cents. I am busted."

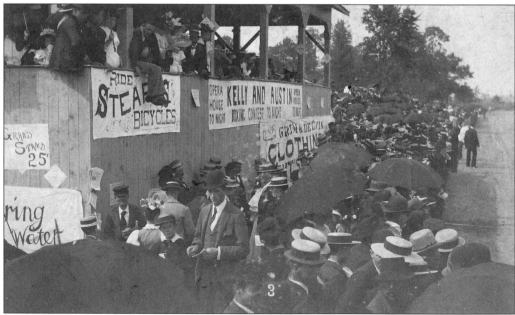

The best cyclists in the country were attracted to the Grove Park Race Track. With crowds that exceeded 2,000, the track provided an exciting afternoon for the occasionally bored bathers. The track was located off Hubbard at Park. Races were often three-day affairs that went on rain or shine.

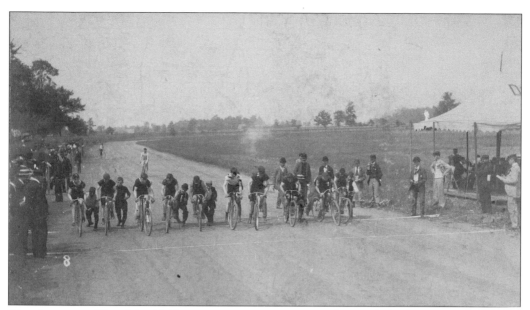

Bicycle races, like this 1895 competition, were popular with bathers and residents alike. Some, however, preferred the horse races available at a track just outside the city in Harrison Township. Opened in 1900, the Clinton Driving Park featured paramutual betting. In the winter the horse races were moved to the lake. Laws were eventually passed to ban races on ice and paramutual betting.

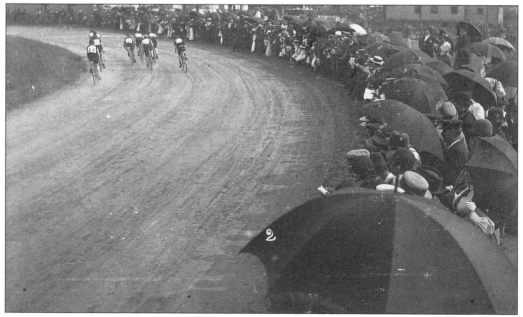

With the advent of the automotive age, racing took on a new thrill. The first auto racers were outlaw drivers who "sped to bloody deaths." In 1950, Dr. and Mrs. Clayton Stubbs reopened the Harrison Township track as the Mount Clemens Race Track. In 1954, they created the world's only auto-boat race track with a lagoon inside the track.

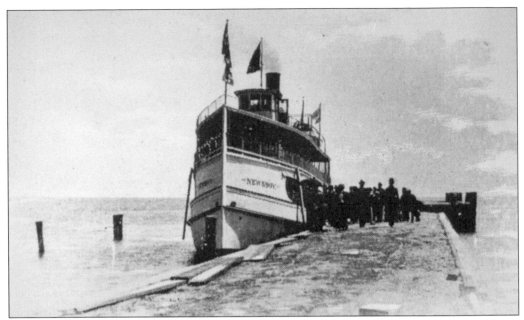

Lakeside had a long pier that allowed larger steamers to drop guests for the Bath City without having to negotiate the winding river. Here the *Newsboy* disembarks passengers perhaps from Detroit or any one of the small cities in between. Guests to the Bath City could also board the steamer for a pleasant lake outing or a trip to local hot spots.

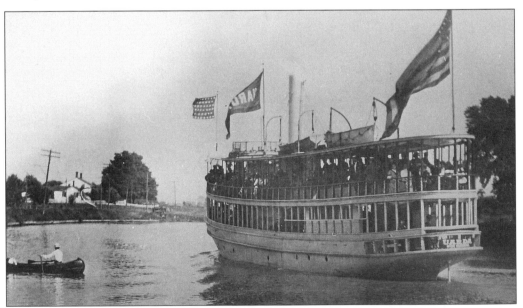

The *Uarda* was another steamer that made regular trips across the lake to interesting destinations like Walpole Island, the Canadian Indian reservation. The channels between Lake St. Clair and Lake Huron were dotted with exciting clubhouses and swimming holes. The most popular was the Tashmoo, an elaborate park filled with all types of entertainments.

On the Clinton River, Mt. Clemens, Mich.

A relaxing pastime for bathers was cruising on the river and lake. According to *Headlight*, "The Clinton River is one of the most charming and romantic streams in Michigan. . . It abounds in cozy nooks of charming beauty. This winding and attractive stream flows through and around the city, affording an excellent opportunity for boating. . . "

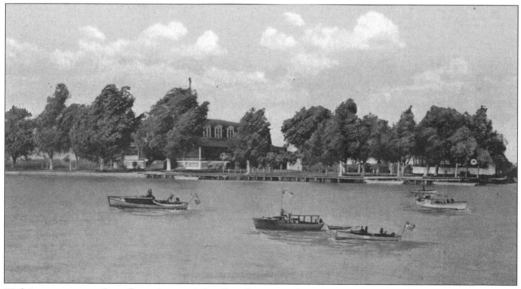

Fishing was another favorite activity for those making a sojourn in the city. *Headlight* extols the excellent fishing in the area. "Fishing excursions are made up any pleasant day in the fall season, parties of from fifteen to seventy-five go to the lake or to the flats, either for a full or half day. . . Short trips are made to the marsh of the Clinton River where the fish caught are largely perch."

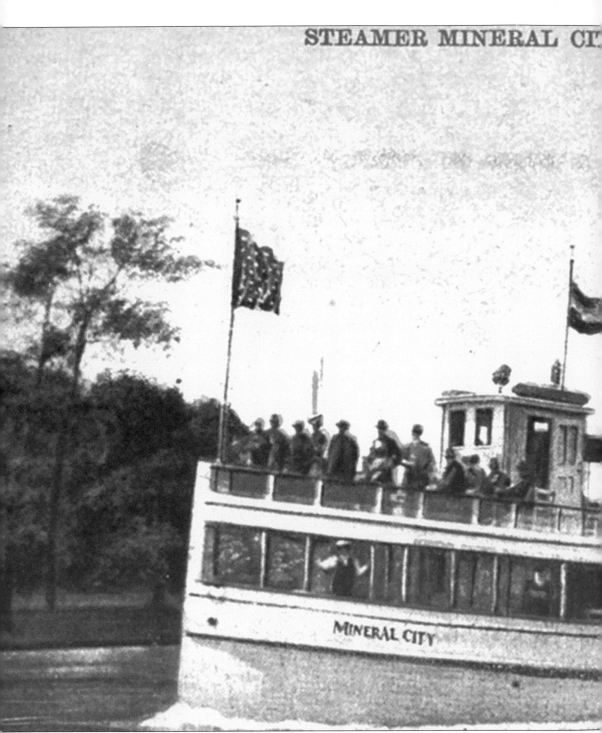

The steamer *Mineral City* was one of the largest and most popular of the excursion boats catering to the bath house visitors. Built in Mount Clemens by William DuLac, she was 70 feet long, and had a capacity of 210 passengers. Captain and owner, Bert DuLac, had a busy schedule taking passengers to Walpole Island, the Indian reservation, on

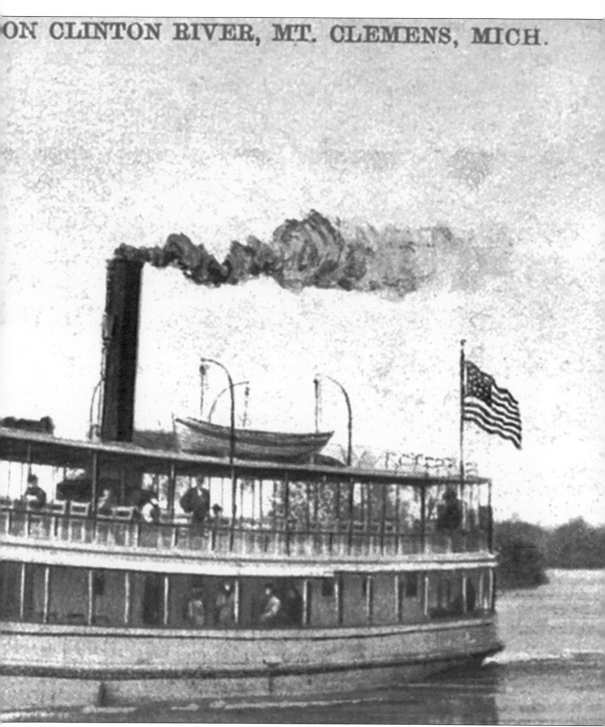

Tuesdays, Thursdays, and Saturdays, and chartered fishing parties on Mondays, Wednesdays, and Fridays. Sunday was a special day when visitors could board the boat to the St. Clair Flats. Pick-up points included the Macomb Street dock and the Avery House dock.

4821. Street Scene, Mt. Clemens, Mich.

This Mount Clemens street scene was typical of all resort towns during the postcard era. The red building on the left sports a large sign that reads, "Postcards." In a popular health spa, bath houses, hotels, parks, and streets were recreated on postcards for visitors to send home to family and friends or to keep as souvenirs.

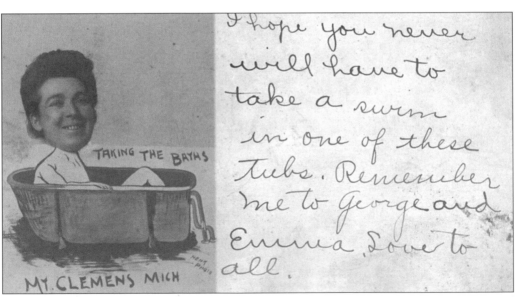

TAKING THE BATHS

MT. CLEMENS MICH

I hope you never will have to take a swim in one of these Tubs. Remember me to George and Emma. Love to all.

Not content to just reproduce what was already in the city, some postcard photographers used every opportunity to sell their cards by personalizing them. By incorporating the sender's image in the scene, the photographer could create an unlimited number of unique cards. While this card is humorous, the tub is extremely unrealistic.

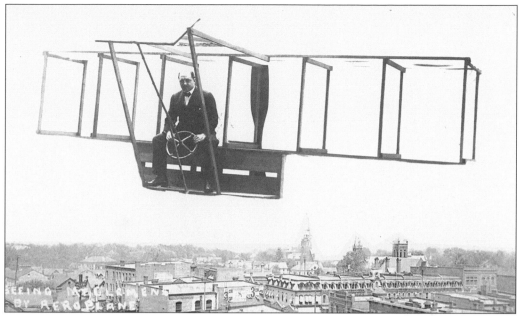

This postcard is particularly interesting when compared with the card depicted on the cover. Some time between 1911, when this card was sent, and 1913, realism must have become more important. Apparently the sender of this card wasn't phased by the lack of believability since the message read, "Expect to make a trip to your house in a few days in my new aeroplane."

Even the distinguished hotel owner John R. Murphy couldn't resist the lure of the personal postcard. It is unlikely that alligators ever inhabited the swamps of the Clinton River or that Murphy ever wrestled one to the ground, but this card has been treasured by family members for many decades.

Mount Clemens, Mich.

GREEN TREE
CHAS. A. JAEGER.

The Green Tree, which still stands at the corner of Main Street and Market, was one of the many bars that catered to Bath City guests as well as locals looking for an evening's entertainment. Over the years it has gone through several name changes and currently is known as the Voodoo Lounge.

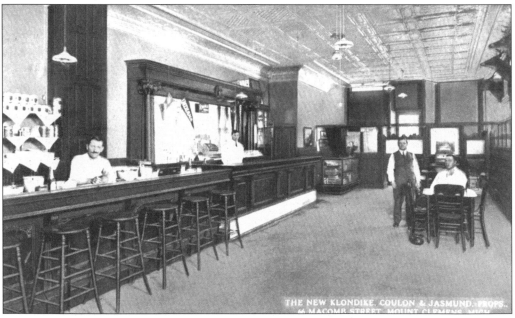

THE NEW KLONDIKE, COULON & JASMUND, PROPS.,
66 MACOMB STREET, MOUNT CLEMENS, MICH.

The New Klondike was another of the bars of the era. According to historian Norm Lorway, "There were more gambling places, houses of ill repute, scads of bars, speakeasies. It was just wide open. All of the baseball players in town to play the Tigers would get on the trolley and come to Mount Clemens to have a good time."

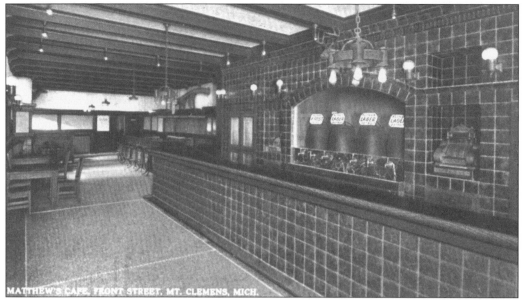

MATHEW'S CAFE, FRONT STREET, MT. CLEMENS, MICH.

While all of the large hotels had their own dining rooms, and most boarding houses furnished meals, some of the smaller hotels offered room and board at separate rates. For those who chose to pay only for their room, small cafés like Mathew's provided alternatives. Located conveniently at 179 Front Street, it was also a good stopping-off spot for shoppers.

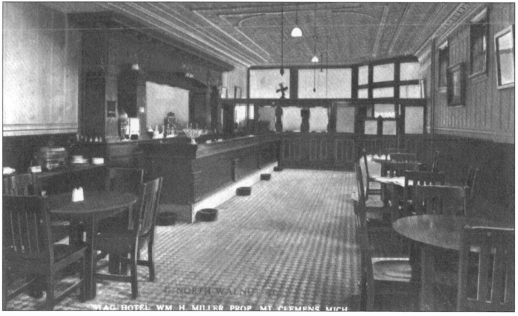

STAG HOTEL, WM. H. MILLER PROP. MT. CLEMENS, MICH.

The Stag Hotel bar was typical of the city's many "watering holes." A New Yorker in town for the baths penned a poem decrying the situation. She wrote, "She has too many cheap saloons, cafés, buffets, and drunk buffoons; These failings she must mend." Obviously the city didn't take the criticism to heart. In 1980, Mount Clemens still had more bars per capita than any other community in the county.

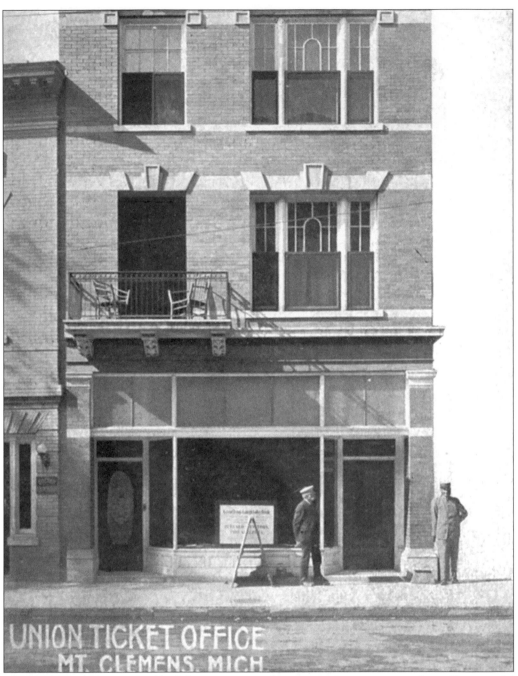

UNION TICKET OFFICE
MT. CLEMENS, MICH.

It would seem that with all of the coming and going in the city, any ticket office would be a good business. Two trains a day arrived in the city, as well as boats and the interurban. Later there were buses and taxicabs. Strangely enough, the message on the back of the postcard reads, "I purchased this business (and lost my shirt)." Perhaps the writer just wasn't a good businessman. The postcard was never mailed, so there is no postmark to indicate what era the card was purchased in or the name of the man who wrote the message.

Although Mount Clemens was known internationally as the Bath City, it was also renowned for its roses. Often called the Rose Capital, the city has seen greenhouses expand and flourish since the first John Breitmeyer moved his business to the city in 1882. During the 1920s, 10 rose growers, totaling more than 30 acres of flowers, earned a million dollars annually. With the demand for flowers produced by the lavish parties and balls at local hotels, the industry boomed, but Mount Clemens roses were also in demand throughout the country. Most rose gardens became family affairs with one generation handing down the responsibilities and know-how to the next.

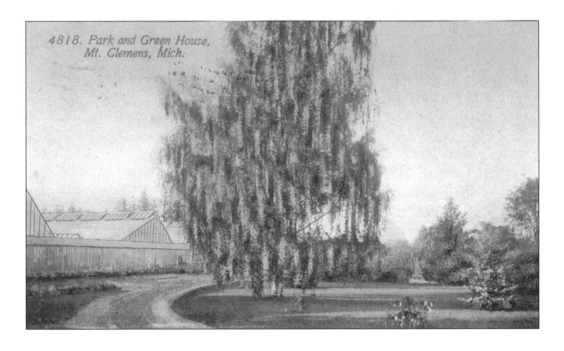

4818. Park and Green House, Mt. Clemens, Mich.

According to a 1918 ad, the Allenel, at 40 South Gratiot, was "equipped with all the latest appliances for the successful treatment of diseases." They had hot-air and electric light baths, static and violet ray treatments, massage by skilled attendants, and many other potential cures for chronic illness. A.B. Allen, M.D. is listed as manager. It was later known as Grace Hospital.

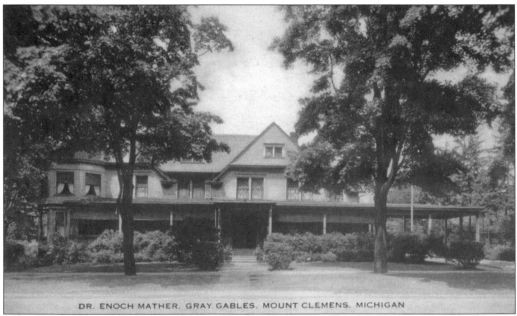

DR. ENOCH MATHER, GRAY GABLES, MOUNT CLEMENS, MICHIGAN

Gray Gables, located on South Gratiot, was a private sanitarium run by Dr. Enoch Mather. The early ads said they specialized in the treatment of chronic rheumatism, along with skin, blood, and nervous disorders. Often visitors preferred the smaller, estate-like facilities to the large bath houses. In the 1960s it was yet another victim of fire.

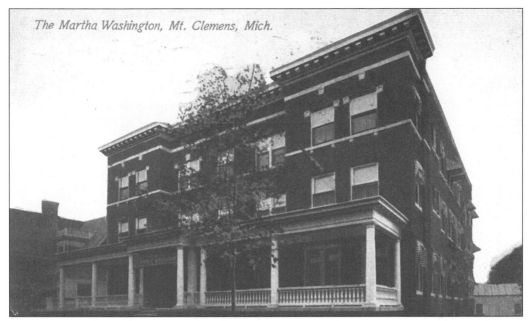

The Martha Washington, Mt. Clemens, Mich.

The Martha Washington Sanitarium, located at 117 Cass, was one of several small facilities where locals and visitors could seek medical attention. Visiting hours were strictly observed so that nurses could see to their charges. The hospital was open until 1919, and was later known as the Washington Apartments. The building is still in use today.

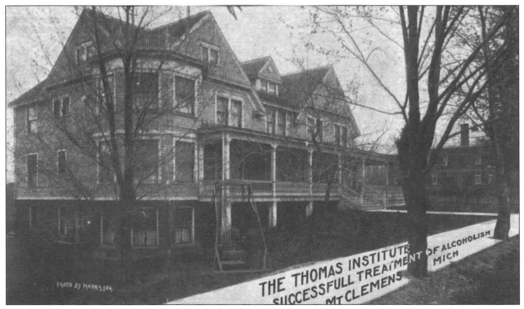

The Thomas Institute for the Cure of Alcohol and Inebriety could be found at 87 Macomb Street. An early ad promised, "Upon the theory that alcoholism is a disease, we furnish a medium not only to antidote the alcohol poison, but to correct the diseased condition of the nerves, stomach, liver, kidneys, and other organs affected, therefrom." This cure "makes you new in body, new in mind."

Last, but far from least, were the nationally known entertainers who came home to Mount Clemens for the off-season. The Flying Nelsons, pictured here, were billed as the "World's Greatest Acrobats" in the early 1900s. They traveled the country with famous circuses like Ringling Brothers and Barnum and Bailey. Born Robert Hobson, Bob Nelson led the way for four generations of Nelsons who thrilled circus audiences for decades with their trapeze act. The Nelson Opera House attracted other high-priced entertainers who often performed spontaneously on city streets. Other famous performers who called Mount Clemens home were ventriloquist the "Great Howard Miller" and the William Kibble family. The Kibble theater troupe included Shetland ponies and dogs that fascinated local children. When they traveled, the Kibbles rode in their own private railroad car.

INDEX

SOURCES CONSULTED

Centennial History of Mount Clemens
Headlight, Souvenir Edition
The Macomb County Library history file
Pageant of Progress
Mount Clemens: Mineral Springs
Made in Mount Clemens
The Mount Clemens Library history files
"And So They Were Married," a personal account
175th Anniversary Book of Mount Clemens Area Michigan

Cutter's Guide to Mount Clemens
History of Macomb County, Michigan
The Past is the Future
Mount Clemens: The Bath City
Mount Clemens: Yesterday and Tomorrow
Mount Clemens: the Bath City of America